50 Distinguished Contemporary Artists In Glass

'Glass shows thousands of different characteristics depending on the light. We have taken up the challenge of showing how 50 artists in glass through the world and across time have used it.'

Dr Judith Neiswander,
Stained & Art Glass

First Published in 2006 by

The Intelligent Layman Publishers Ltd
Thornton House
Thornton Road
Wimbledon
London
SW19 4NG

www.ilpublishers.com

© copyright 2006 Intelligent Layman Publishers Ltd

ISBN 0947798609

Printed in Slovenia by Compass Press Ltd

Contents

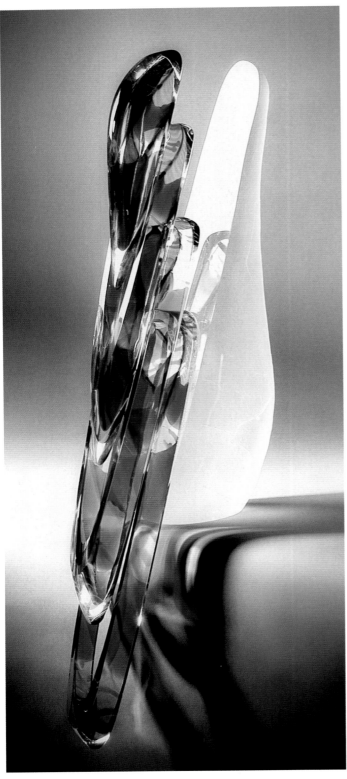

'Postmeridian' by David Flower, 2006.

This book has been created by the best 50 talented artists in the world who have a passion for glass. This is vital to them as they design and create their breathtaking works.

We have chosen works which are considered to have achieved the highest standard in the contemporary world of glass artists and which explore their fascination for light and its relationship to glass.

This book is unique, because the selected contributors have been intellectually and emotionally involved in their contribution.

We hope that the understanding of colour and light which has impressed us will also impress you.

We shall continue bringing to your attention the best in glass art and welcome any contribution and criticism of what we are attempting to do.

Australia

Catherine Aldrete-Morris

'It is the play of the form which captures my thoughts, allowing me to visit and reconsider. Influenced by minimal art and architecture, the forms alter between dominant angular structures to curved impressions in mid-posture to 'become'...'

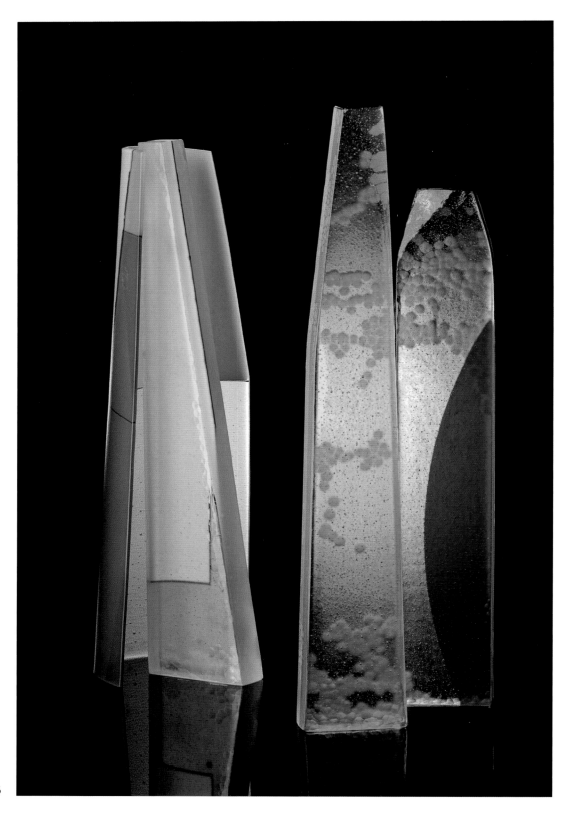

'Sisters', 2005

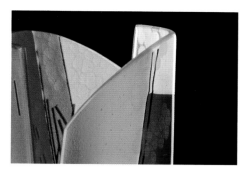

'Courting' (detail), 2005

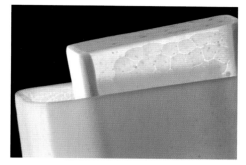

'Muted' (detail), 2004

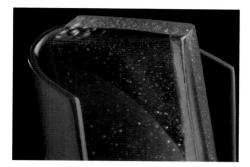

'Manly' (detail), 2005

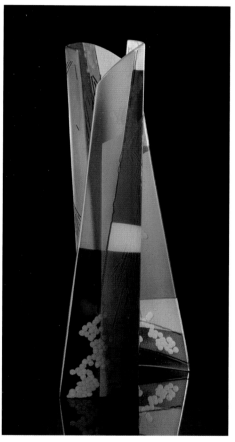

'Courting', 2005

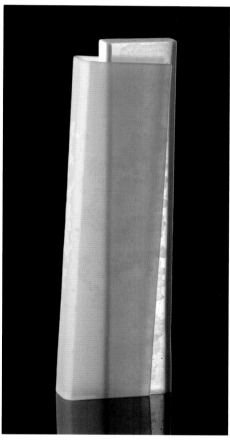

'Muted', 2004

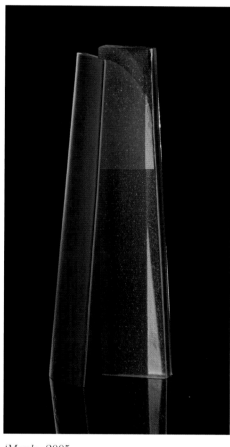

'Manly, 2005

Catherine Aldrete-Morris' work is kiln-formed to make the base bodies. It is then identified by hand and machine, creating and illuminating texture within the sculptural object. Practical applications she has collected from previous disciplines find their way into the work via colour blocking, design principles and technical formats. After sufficient cutting, the work may then be returned to the kiln for further surface treatment, before the final touches are rendered and the work deemed ready.

Daniela Turrin

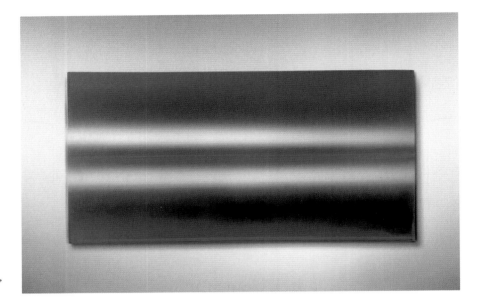

'Chiaroscuro'

Daniela Turrin works from her studio in Camperdown, Sydney. She holds a Master of Visual Arts degree from Sydney College of the Arts.

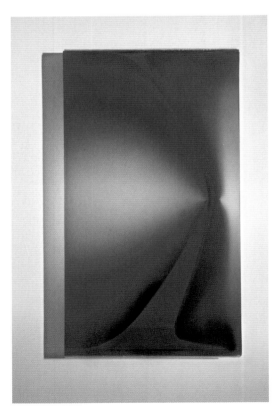

'Abyss'

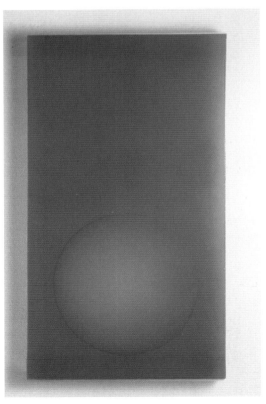

'Hover'

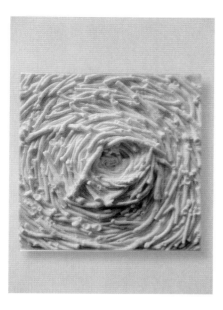

'Glimpse'

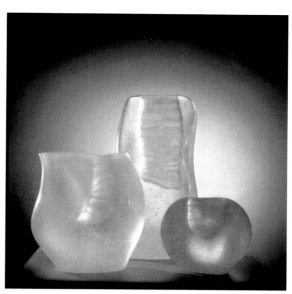

Turrin describes her practice as an exploration of aesthetic experience in terms of a disruption in our conventional sense of space. She considers glass to be an optimal medium for this project in that it lends itself naturally to portraying notions of presence and absence. The investigation of three-dimensional experience through a planar surface may arguably be deemed classically painterly even though it is achieved through a solid three-dimensional glass object.

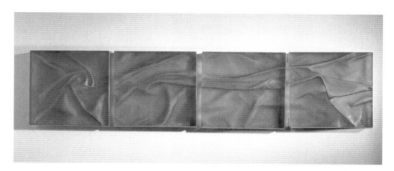

'Entwine'

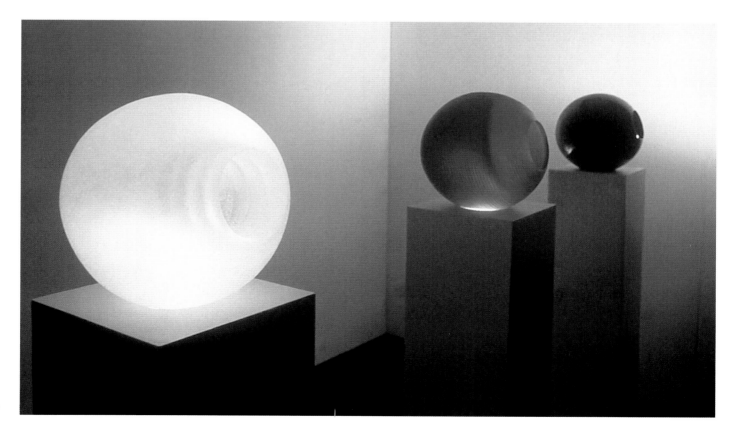

'Immaterial'

Gerry King

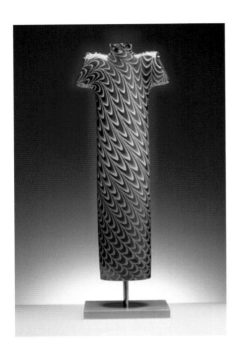

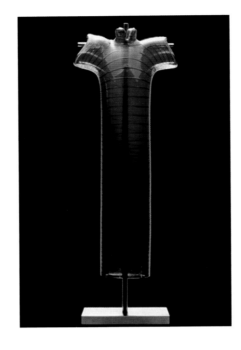

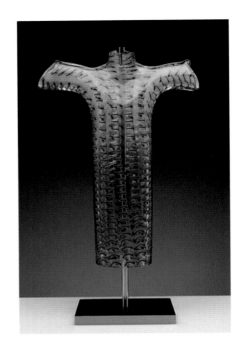

'The Semblance Series':
is a reinvestigation of King's Yukata works from the early 1980's.
Returning to a form is, to some extent, an indulgence requiring
considerable study and the retrieval of skills long lost.

Now, some 20 years later *Gerry King* has adopted the completion of the
Yukata Series as the commencement of the Semblance Series and works
with a team of glassblowers. The three person team required to shape
the works enables enlargement and modification of the piece beyond
that which he could originally produce alone. Inevitably, the Semblance
works are developing towards forms quite removed from that of the
Yukata and like the other series shown here are propositions that such
objects might exist just as archaeological collections represent theories
rather than absolutes.

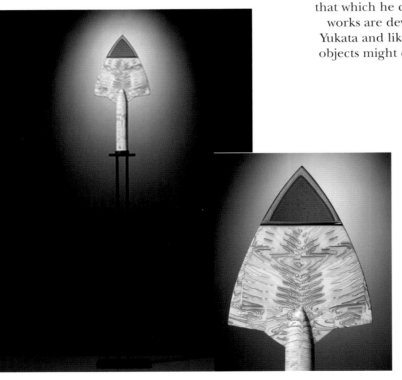

'The Toledo Blade Series':
is inspired by and pursues the artist's interest in
the duality of existence, the manner in which one
event, circumstance or artefact can be perceived
differently by various participants or indeed by an
individual on various occasions.

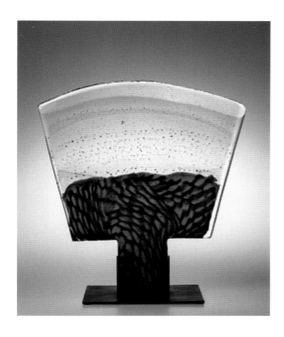

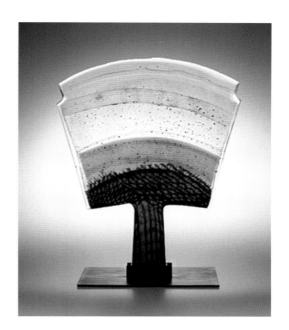

King was born in Australia in 1945. He has been engaged in contemporary glass since 1973 when he undertook a Master's Degree at Alfred University in the USA. Originally trained as a glassblower, he has concentrated on kiln working since the 1980s. Awarded a Doctor of Creative Arts in 1993, he has various academic qualifications from Australia, Canada, and the USA. He helped to develop the glass program at the University of South Australia and has lectured, demonstrated, and taught in countries throughout the world. King is a founding member of AUSGLASS and the immediate past Chairperson of the Board of Directors.

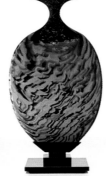

'Tartessos Series and Atlantis Find Series': We tell ourselves that there are certainties upon which all can be understood. Yet the demise of 'unsinkable' ships is legend, the 'war to end all wars' didn't. Societies labelled 'primitive' had and/or have complex understandings of society, medicine and the environment and sparing the rod hasn't spoilt the child.

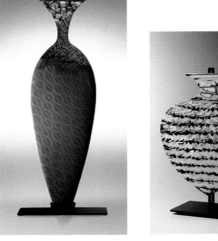

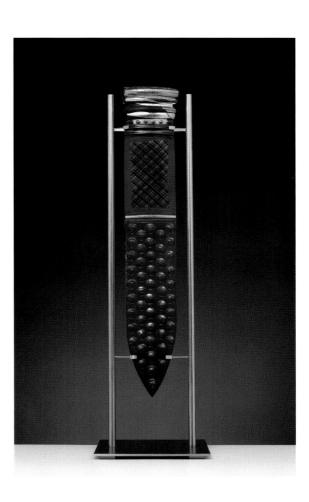

Judi Elliott

A painter and colourist at heart *Judi Elliott* is well known for her painterly style and vibrant palette. Strong primary and secondary colours - especially her trademark reds and oranges denoting positive life forces and black, representing the drama of life, are still widely used.

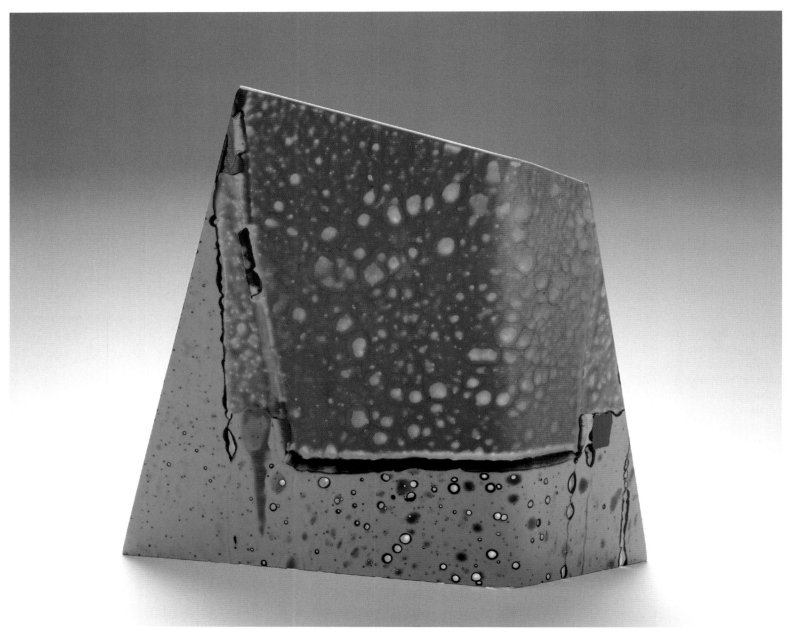

'Yellow House, Pink Roof', 2004

Elliott perceives a close affinity and synchronicity with renowned New York-based contemporary Irish born abstract painter Sean Scully. Both artists appear to share a common aesthetic. Their work is driven by an unwavering belief in the strength of the human spirit and mutability of life, as revealed by their visual vocabulary, imagery, harmony, use of light and colour and the blurring of lines and edges.

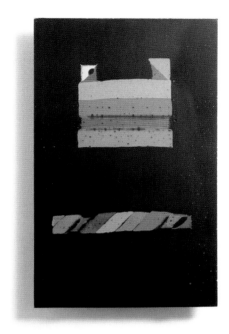 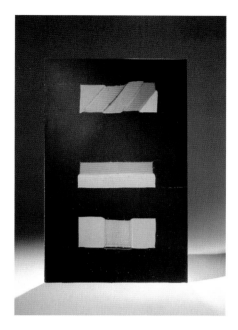 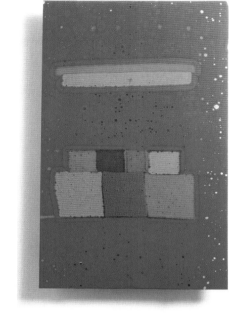

'Architecture In The Landscape' Series, 2005

Elliott's journey began with an obsessive urge to draw and paint as a child. As her love of design, architecture and buildings, coupled with an enjoyment of literature and music, grew, it became clear that she was destined to be either an architect or a visual artist. In 1983, she enrolled in the Glass Workshop at the Canberra School of Art headed by internationally renowned glass artist Klaus Moje. When she graduated two years later with an Associate Diploma, her own 'language' and unique style were already firmly in place.

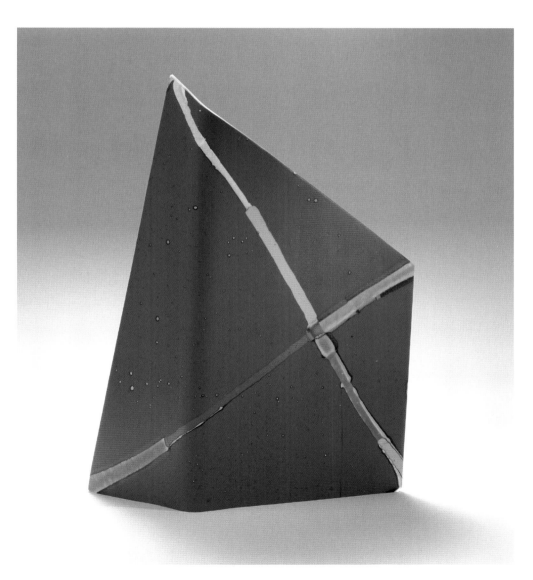

'Across the Wall 2', 2004

Julia Dunn

Julia Dunn is a self-taught artist with skills in painting, drawing and glass. With over 20 years experience in stained glass, leadlight and etched glass design, much of her past work was of a traditional and functional style, primarily for a leading leadlight/stained glass business in Melbourne, Australia, but also freelance design and private commissions.

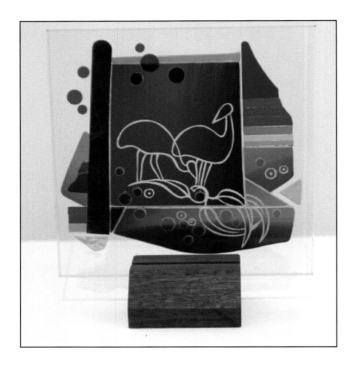

'Australis 3' (on the left), 2006:
Primarily inspired by the colours and life within the glass and a desire to create an original interpretation of the uniqueness of the Australian landscape.

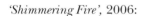

'Shimmering Fire', 2006:
Often it is the glass itself that dictates the design and subject of a piece and Shimmering Fire is such an artwork.

Born from the aliveness of the rich red antique glass that evoked a story of deep driving passion and the sometimes vacillating, fragmented and punctuated journey of life.

Depicting the wisdom that grows from life experience, a steady, assured shimmer, but yet still containing an uncertainty and mystery perhaps to unfold.

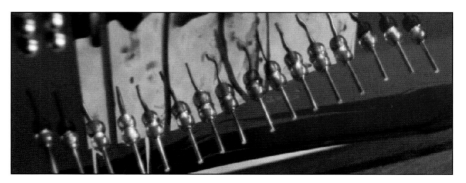

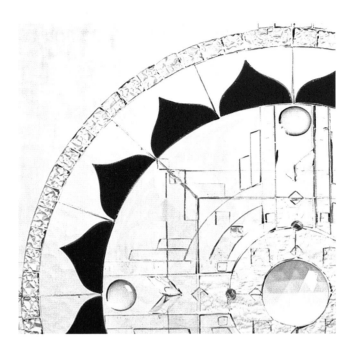

'Serenity' (detail), 2005:
Order, structure and balance are design elements employed in this contemporary mandala to give form to a representation of focus, contemplation and the spiritual building blocks of life.

As in many of my works of this nature, universal and ancient symbolism is used, along with the qualities and textures of clear glass and in this piece, a deep, but rich blue (that is often associated with spiritual learning and spirit) has been used - all assist in giving an ethereal yet grounded feel.

For the past 8-10 years Dunn has been exploring the technique of layering and gluing glass to glass - one example being the fabrication of a 6 x 3m "Glass Tapestry" for Klaus Zimmer, which is installed in the Sacred Heart Church, Croydon, Victoria, Australia. Most of the artist's work is now of a more intimate nature, such as the ones pictured.

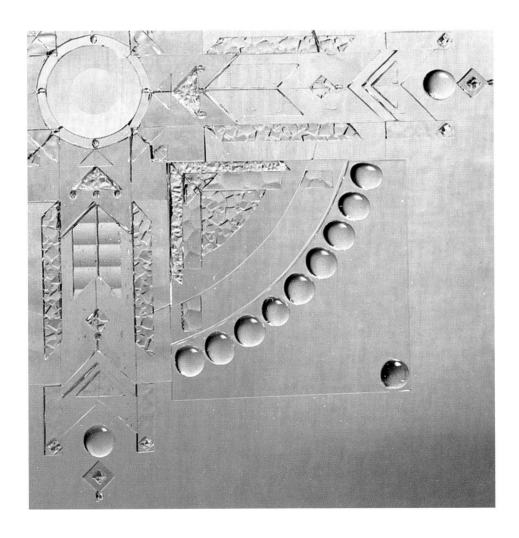

'Saisons' (detail), 2005:
Commissioned to represent the healing and teaching interests and practice of the client and the cycles of 'life, death, life'.

Using only clear glass (of various textures) it is at once no colour and all colours and a symbolic representation of clarity, wholeness, unity and balance.

Marc Grunseit

Marc Grunseit took up glass in 1979 and in 1982 sold his medical practice to pursue it full-time. He has completed numerous commissions for domestic, ecclesiastical and public buildings and participated in group and solo exhibitions in galleries worldwide, with various pieces held in public, private and corporate collections. Grunseit was the elected National President of AUSGLASS from 1989-1990.

'Magpie Dawn TGV'

'This Land TGV'

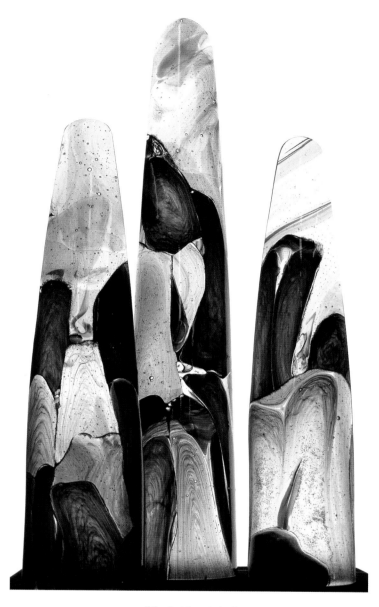

'Magic Mountains'

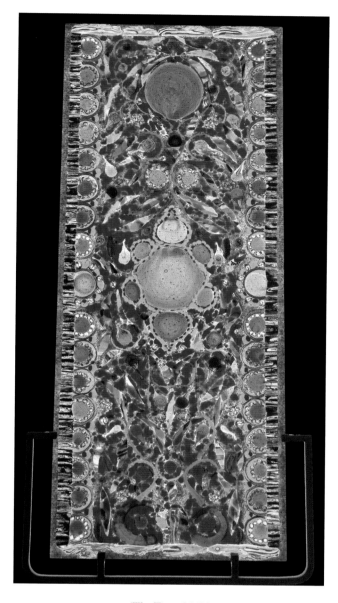

'The Tree of Life'

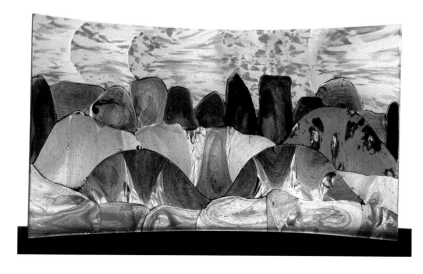

'Red Hill'

The scope of his work ranges from 35 sq m architectural installations to delicate pieces of kiln formed glass which fit into the palm of the hand. His designs are eclectic and are employed to interpret the natural, social, cultural and mythological Australian environment into unique pieces of glass art.

Scott Chaseling

Originally, having trained as a sculptor, then specialising in blown glass, *Scott Chaseling* introduced other techniques to allow for a broader means to expression. Studies at the Canberra School of Art, followed by times travelling, acquiring further skills abroad, developed Chaseling's highly original glass works. The artist creates pieces which are painted mosaics, fused, blown and wheelcut glass with a strong narrative.

Selected collections include the 21st century Museum of Contemporary Art (Kanazawa, Japan), the Australian National Gallery, and the Museum of American Glass (New Jersey, USA). Selected awards are the Gold Medal Bavarian State Prize (Munich, Germany), The Vicki Torr Memorial Award, the Ranamok Glass Prize, and Cite des International des Arts, Power Bequest.

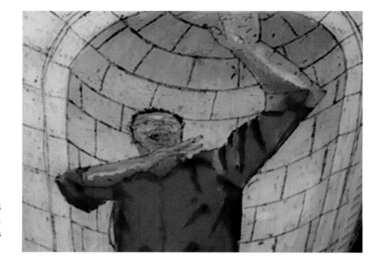

'A certain niche', (detail),2003
50cm x 60cm
Reverse painted glass

'Exit', (detail),2003
Height: 50cm
Reverse painted glass

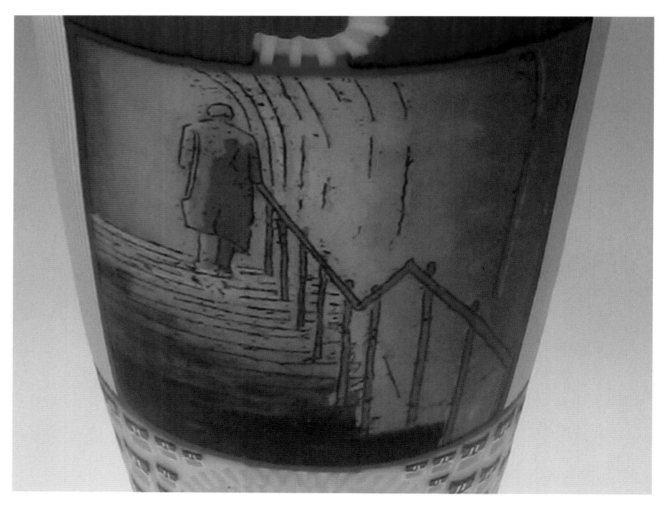

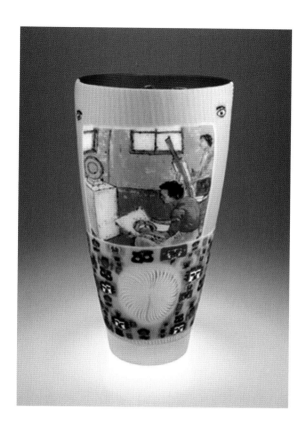

'Amongst the masses',
(side B),2004
Height: 52cm
Painted and fused glass

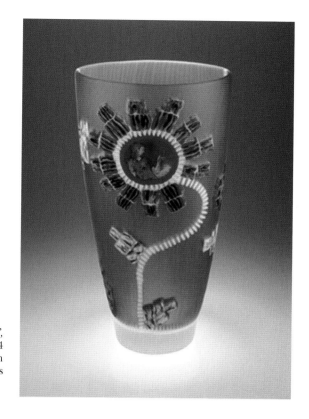

'Amongst the masses',
(side A),2004
Height: 52cm
Painted and fused glass

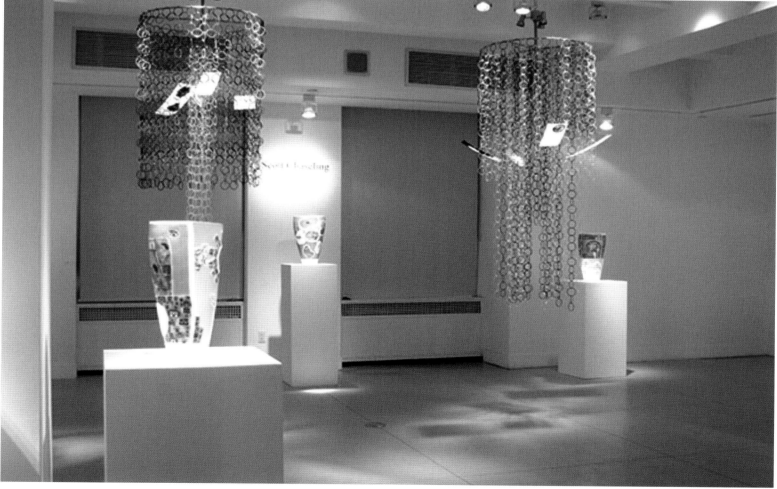

Exhibition View – Leo Kaplan Modern Gallery, New York, 2004

Stephen Skillitzi

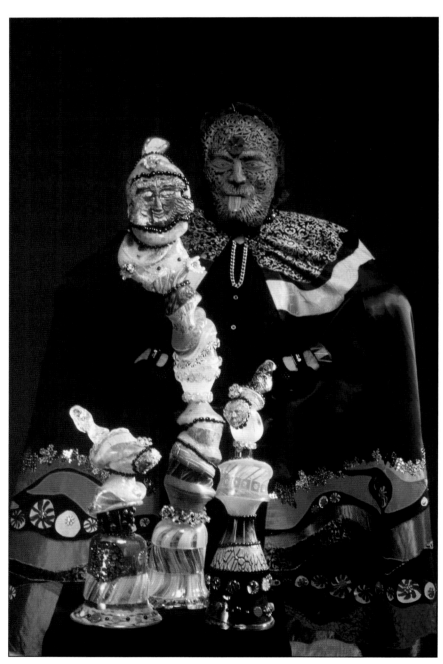

Having introduced "Studio Glass" to Australia via the very first glassblowing demonstration (Sydney, Feb 1972), *Stephen Skillitzi* has recently revisited the glass furnace with an innovative style that has opened the door to unique multiple colour and pattern effects within a single blown item.

'The Ventriloquist and 3 puppets'

'Puppet' (detail) of
'The Ventriloquist' performance

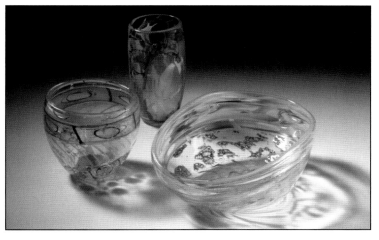

Traditionally 'graal' and 'encalmo' are two unrelated techniques. But Skillitzi has succeeded in exploiting 'unchartered waters' by hot forming/blowing up to ten separately-designed 'graal' rings which are then restacked then reblown into simple, functional vessels or sculptures. Because the stacked-up combinations are pre-planned at Skillitzi's leisure when the glass rings are cold, the final colour/pattern/form has a high degree of visual control and discretion. This is virtually impossible with hot formed creations.

3 vessels, blown, (graal/encalmo)

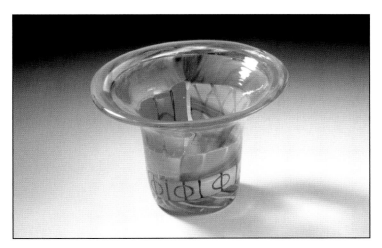

Bowl blown, (graal/encalmo)

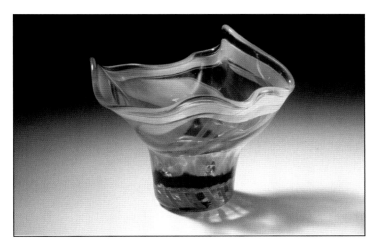

'Firewater Wave'

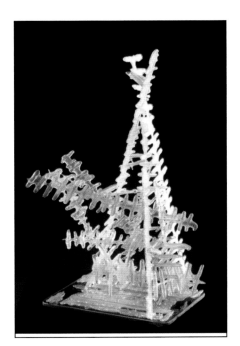

'A-Frame Ladder'

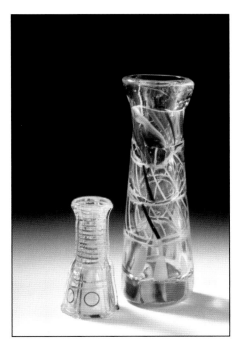

2 vases, blown, (graal/encalmo)

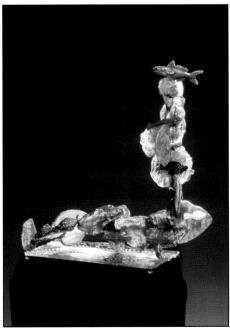

'Marine World'

Tim Shaw

For the past 7 years *Tim Shaw* has resided in the Adelaide Hills where he operates his own glass workshop, one of the few independent hot glass studios in South Australia. In this idyllic and creative environment, Shaw's work has flourished, absorbing an Australian influence. Shaw's pleasure in working with glass is evident to the viewer. His desire is to bring joy into the lives of people through his art glass, and to transmit his passion for colour, light and beauty. Shaw has three degrees in glass blowing. His career spans over two decades and he has worked around the globe. He is a member of AUSGLASS (Australia), C.G.S. (UK) and G.A.S. (USA).

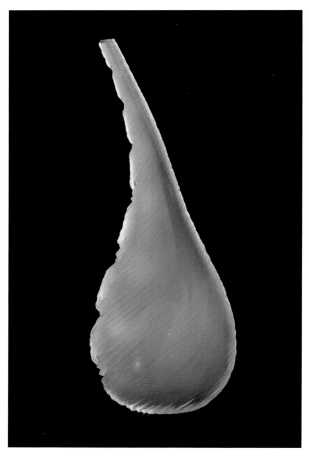

'Summer Cornfields'
evokes a memory of lying in a corn field on a hot summers day, feeling the heat of the sun, looking at the sky and listening to the corn swaying in the breeze.

'Windfall' (detail)

His 'Slash and Cut' series takes traditional blown forms that he slashes and cuts with his diamond saw to carve and sculpt the surface. The holes in the piece serve to challenge the viewers' concept of the vessel as well as allowing the object to be viewed simultaneously from within and without. This process is dangerous and exhilarating at the same time.

Whilst he starts with a vague plan of attack, the piece often dictates the carving process, and all too often the vessel ceases to exist because he oversteps the line, and end up with a pile of broken glass!

This radical approach to carving glass, results in works that are steeped in raw energy, yet possess a refined elegance. This balance between form and fragility, coupled with the pieces' transparency, colour and surface texture allow him to create objects that are uniquely beautiful.

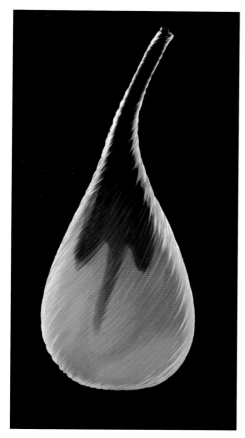

'Summer Incandescence',
the heat of summer and the
moment before the thunder
storm breaks.

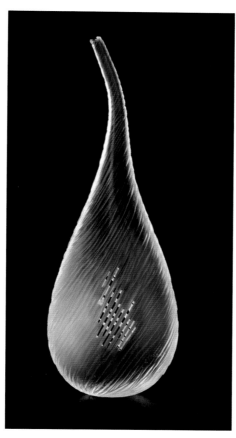

'Stratosphere'
takes the mind to the upper levels of
the atmosphere and makes Shaw
think of his place in the universe.

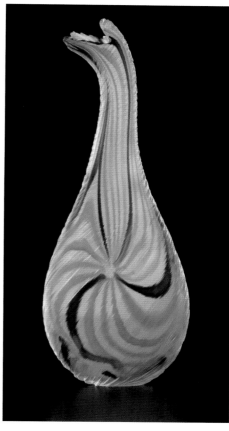

'Flare'
is like a flash in the sky with beams of
colour radiating out from the centre.

Flare is made by blowing a bubble of coloured glass and overlaying this with subsequent gathers of clear glass. This piece incorporates the use of cane work whereby canes of glass are made by drawing out various colours of glass. These canes are then incorporated into the piece during the blowing process. The whole is then cooled and carved using water fed diamond tools. Finally it is sandblasted and sealed with a glass sealer.

Belgium

Thierry Bontridder

"Art recreates the event, it does not imitate it. Thus glass is induced, in certain sculptures by Bontridder, to recreate the event of light. It is not only its transparency that is brought to bear, but also its power of refraction. The fluidity of the material gives the composition its weightlessness, its ethereal quality, while the alternation of elements ensures a measure of sustained rhythm. Here, light becomes matter rather than medium (an intermediary between the gaze and its object), extended matter which exhibits a whole series of radiations, of intensity thresholds passing from bright to darkness…"

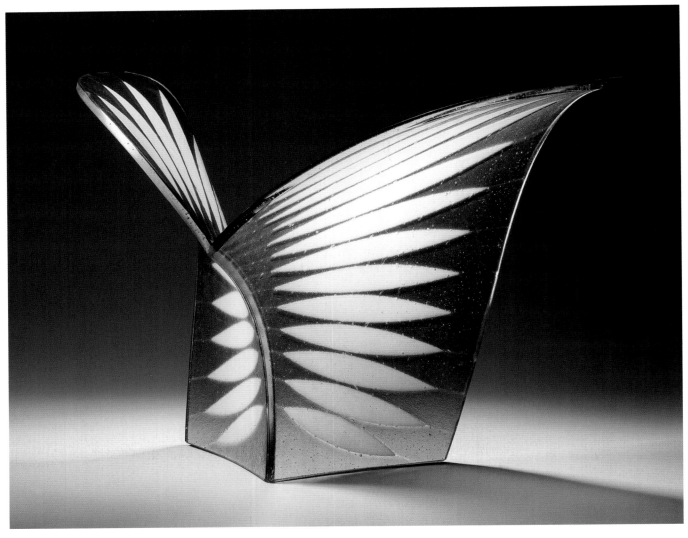

'Grey Wing'

"As light crosses the levels of these glass bridges, it condenses in straight lines that fall in parallel through the void like the atoms of Epicurus. It is a "rain" of atoms, an avalanche of luminous fibres which, as long as nothing alters their trajectory, are content to define an environment where nothing has taken place - other than the infinite free-fall of parallel paths."

Luc Richir, in' Dieu, le corps, le volume '- Essai sur la sculpture Editions La Part de L'Oeil (2003)

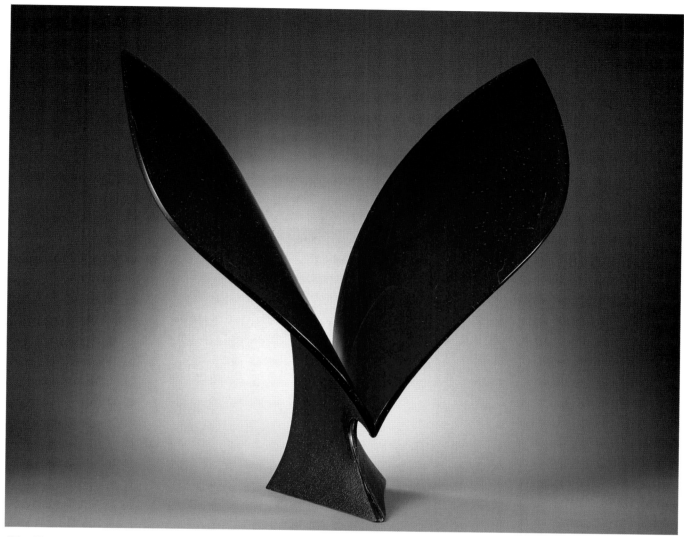

'Blue Wing'

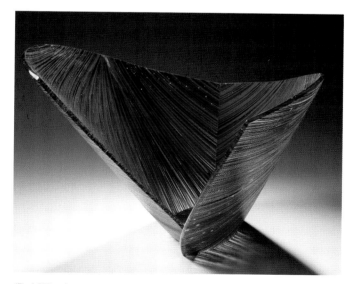

'Red Wing'

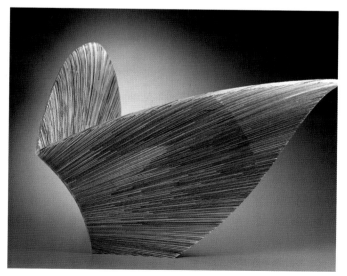

'Red Wing'

Canada

Peter Powning

Glass, cast iron, bronze, stone, Corten steel and stainless steel are materials that will all stand the elements over a prolonged period. It is not *Peter Powning's* intention that the outdoor work be completely unaffected by exposure. The work is meant to 'settle in' to its site and mature with age, taking on a site-specific patina as a result of sun, wind and rain.

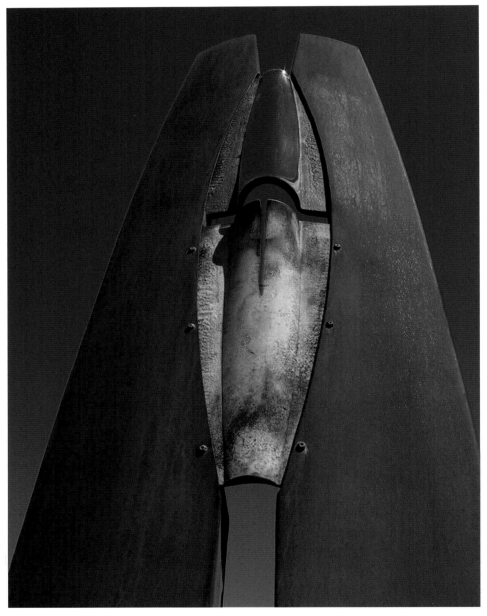

'Crux Big Out'

The granite used in Powning's work is unaffected by the weather. Other materials may leave minor stains on the stone's surface as the sculpture becomes rain washed. Glass is essentially impervious to the elements but obviously can be damaged by vandals or being struck. Combined, these materials give the sculptures a complexity and richness that improves with time.

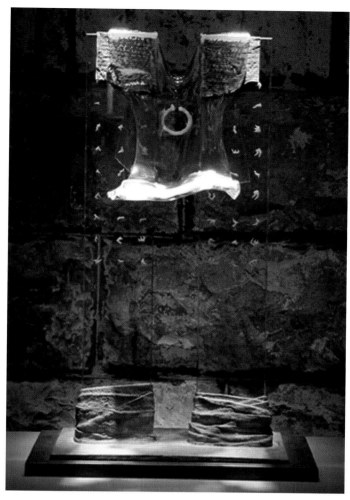

'Torn Self'

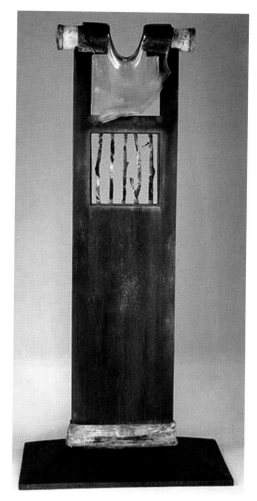

'Open Self'

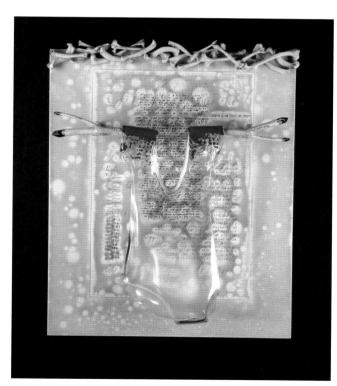

'Self White Front Wall'

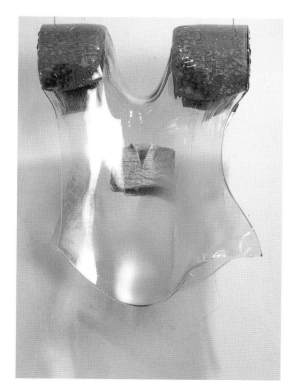

'Interior Self'

Denmark

Anne K Kalsgaard

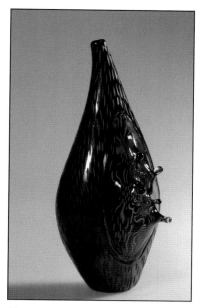

'Aggressive', 2002

Anne K Kalsgaard strives to create objects that speak of specific feelings she wants herself and others to touch. She makes translations of her personal feelings and wishes and expresses them visually using glass.

Her work is often about tension and contrast - clashes between different forces.

Both the physical and emotional forces.

It is about the imprint we leave on others and the world around us and vice versa.

It is about how those imprints change and mutate us.

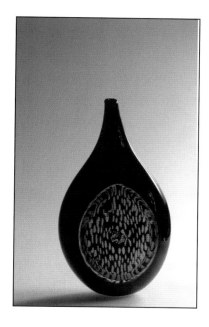

'Light Through Leaves', 2002

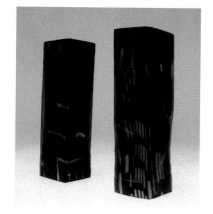

'Skyscrapers of Mutated Light', 2003

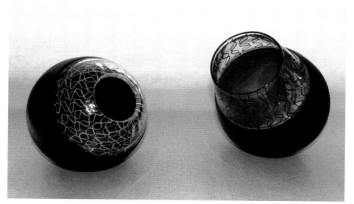

'Identity', 2003

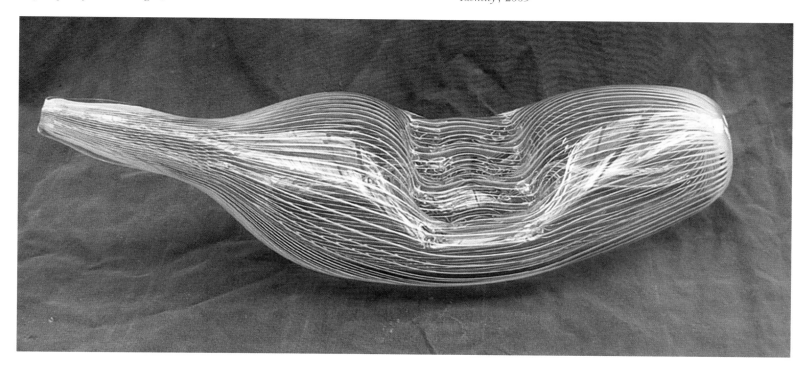

'Roadkill', 2004

Finland

Renata Jakowleff

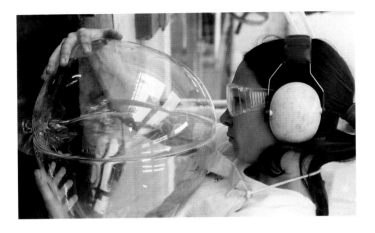

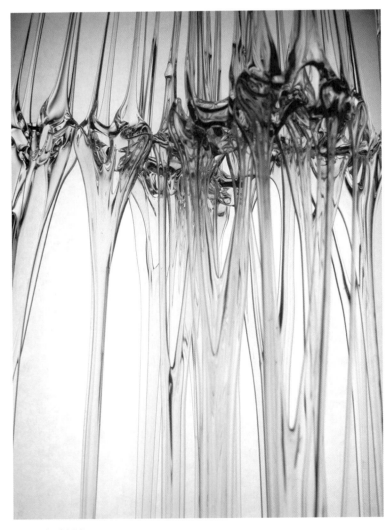

'Hemisphere', Frozen Movement Series, 2004

'Hemisphere' is made of free blown clear glass balls divided in two halves by an exceedingly thin film of glass. The structure of the film is created due to the natural vibrating movement of the film when blown out.

Renata Jakowleff is a Hungarian-born glass artist living in Helsinki, Finland. She finished, in 2005, a Masters Degree at the University of Art and Design in Helsinki. Becoming familiar with different glass technologies, production techniques and approaches in the field of glass, her interest has focused on understanding the molten, hot glass and its behavior. Now, the aim is to turn this practice-based knowledge to theoretical concepts and present them as art pieces.

Molten, liquid glass has the unique capacity of being independently plastic, matching the dynamics and creativity of nature in movement. However, the movement of hot glass always slows down. The quick moment of movement becomes irrevocable history and can only be interpreted from the form of the set glass objects.

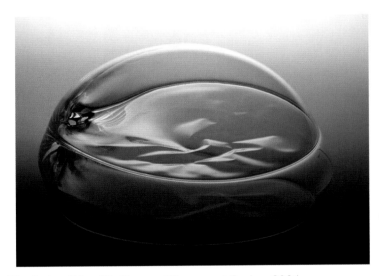

'Hemisphere'(detail), Frozen Movement Series, 2004

'Rain', 2002

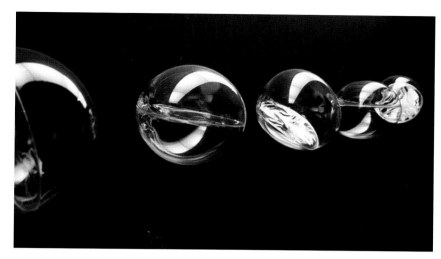

'Hemisphere', Frozen Movement Series, 2004

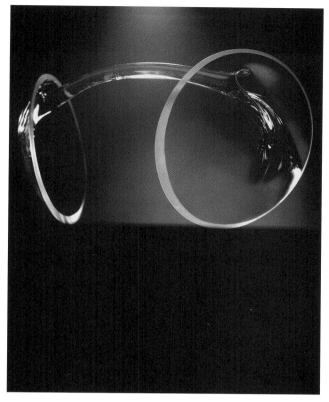

In the work, Jakowleff tries to create channels of movement for the molten glass, following the laws of physics, avoiding forced direction. She expands these forms into narrative segments and reconstructs the movement step by step, aiming at awakening the past movement from its static state and thus conveying the experience of the nature of liquid glass to viewers.

'70%', 2001

'Element', 2002

Iceland

Leifur Breidfjörd

Four aspects of lighting have to be taken into account when designing a stained glass window. Firstly, one has to consider how a window will look from inside during daylight. Secondly, when the same work is illuminated from inside after dusk. This is where the reflection of the colours within the glass and the outline of the lead supports are particularly important. Thirdly, consider the work as seen from the outside in daylight; here its mirror image needs to be taken into account. In fact, one always has to consider the mirror images. Fourthly, when the work is seen from the outside in the evening, lit up from the inside. All of this is very important if a stained glass window is to function properly, twenty four hours a day.

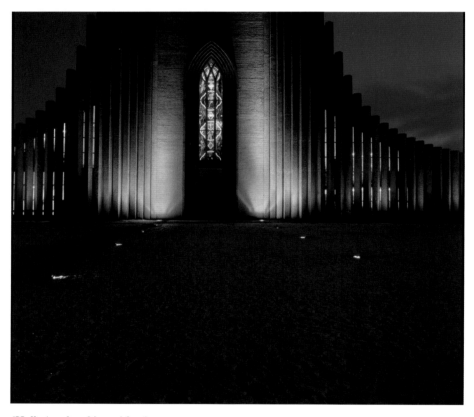

'Hallgrimschurch' outside view

Leifur Breidfjörd has worked in his stained glass studio in Reykjavik since 1968 where he has created most of his works. Some of the larger stained glass works are made in stained glass studios in Germany. He has exhibited paintings, watercolours, pastels and sculptures as well as stained glass during these years. He has won several Icelandic grants and awards, and was the First Winner for the Icelandic pavilion for the World Expo in Seville in collaboration with the architect, Gudmundur Jonsson, in 1990.

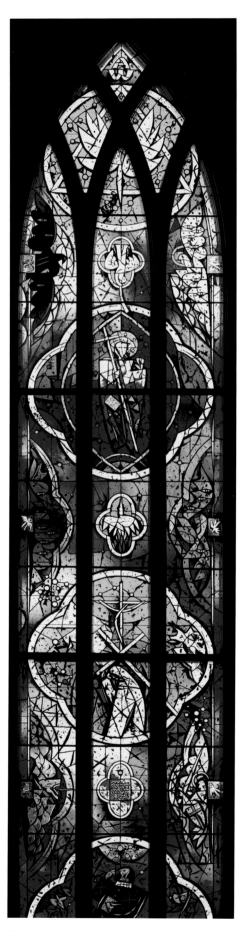

'Hallgrimschurch'

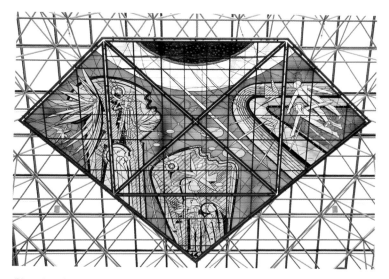

'Yearning for flight'

Improvisation is an important part of Breidfjörd's procedure. Good draughtsmanship and sensitivity to colour are two basic requirements for the successful creation of good glass artwork. An interest in, as well as an understanding of other art forms, is also important. He gets a lot out of visiting exhibitions and art museums; they widen his horizon and stimulate his imagination. He is influenced not only by good stained glass windows, but by all good art.

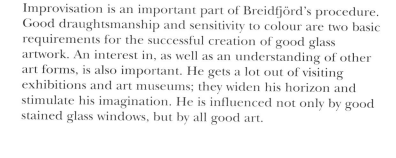

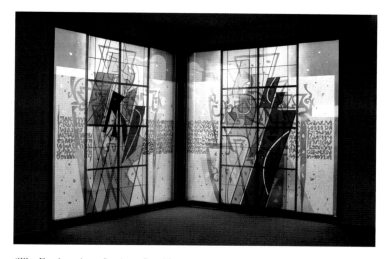

'The Engineerings Savings Bank'

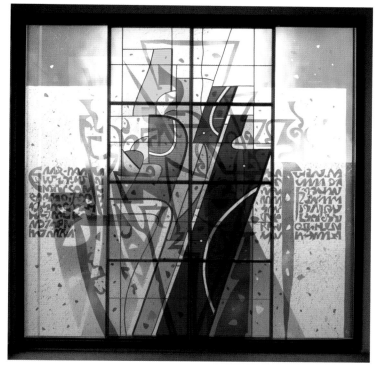

'The Engineerings Savings Bank' (detail)

Close cooperation between architect and artist seems to be of utmost importance, particularly in the case of modern architecture. A stained glass window must always constitute a balanced counterpoint to the building and its surroundings. Although a window is designed according to a certain architectural pattern, and forms an integral part of a building, he always looks upon it as an independent work of art.

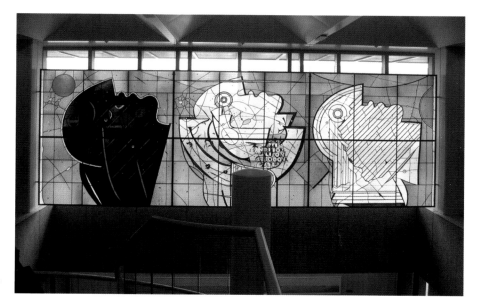

'The National Library'

Italy

Alessandro Casson

Alessandro Casson was born in 1969 in Venice, the city where he lives and works. In the 1990s he started to collect twentieth-century Venetian glass and contemporary paintings. During university, he painted with different techniques and illustrated comics for specialised publications. In 1996, after becoming a Doctor in Political Science and Economics at Padova University, he worked as Marketing and Advertising Manager for the sports market, travelling around Europe, USA and Canada.

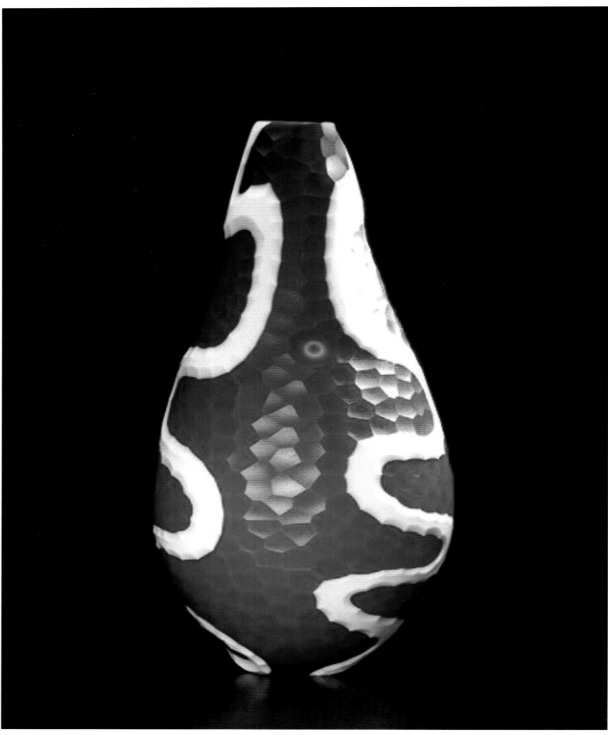

'Anima'

The careful study of the alternation of opacity and transparency allows bands of light to filter inside and outside the vessel.

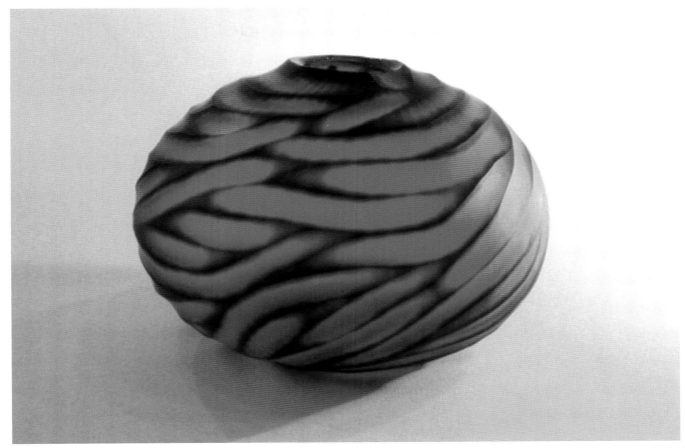

'Fuoco Dentro'

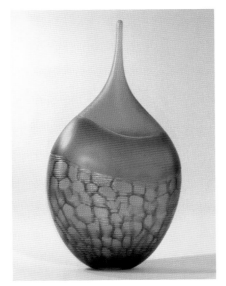

'Stagno'

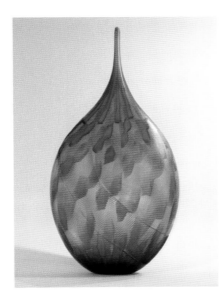

'Arlecchino'

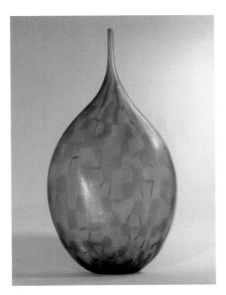

'Acqua'

Casson's love for his hometown was too strong and, in 1999, he opened a glass gallery in Venice. Alongside the sale of crafts (glasses, vases and other objects) exported world wide, he has an increasing collaboration with master glassmakers to execute his own creations with his own brand "Fragile studio". In 2001 he advanced his education in glass by attending lampworking, blowing and fusing seminars and lessons with various glassmakers and international artists in Murano and Tuscany. The production is focused on carving and engraving the blown glass, textured with different and deep grindings.

Japan

Yoshiko Okada

Presently *Yoshiko Okada's* work continues to explore the synergy and paradoxes of her
Japanese background and experiences, and her current English and European situation.
Her key interest is in exploring memory, identity, time and the human condition.
Although seemingly complicated this often leads to simple forms of expression or symbolism.

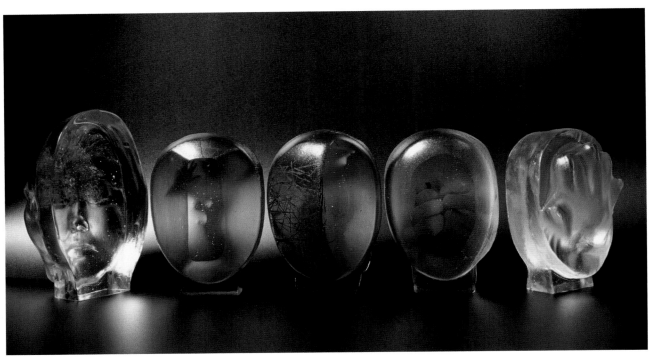

'Back of my Mind - Hidden Soul', 2004

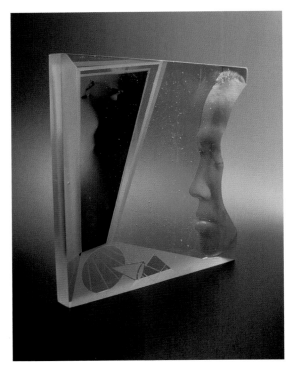

'Dream', 2005

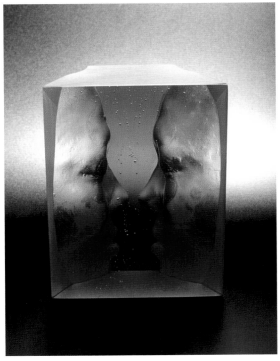

'Two Face', 2004

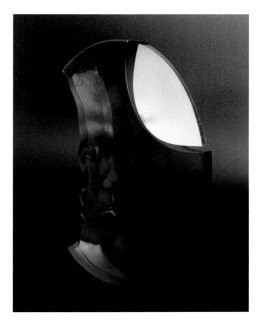

Homage to Shel Silversteins
'The missing piece', 2006

The techniques Okada uses presently are kiln cast glass in life size sections of face and head with additions and subtractions, then detailed with photographically fused self portraiture and sandblasted imagery.

She is also trying to create a 'stage like' theatrical presentation in which a dialogue unfolds within the pieces of glass.

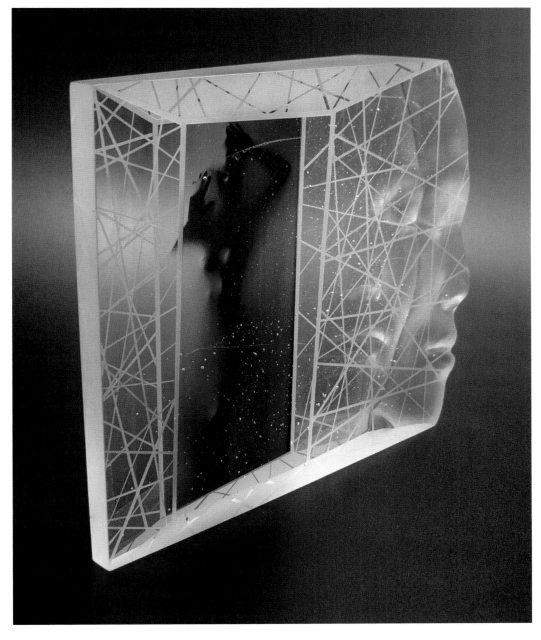

'The Missing Piece', 2004

New Zealand

Emma Camden

Emma Camden has exhibited regularly in New Zealand, Australia and the United States. She graduated from Sunderland University, England, majoring in Kiln Formed Glass and emigrated to New Zealand in 1991. Camden took First Prize in the prestigious Ranamok Glass Competition held in Sydney in 1999.

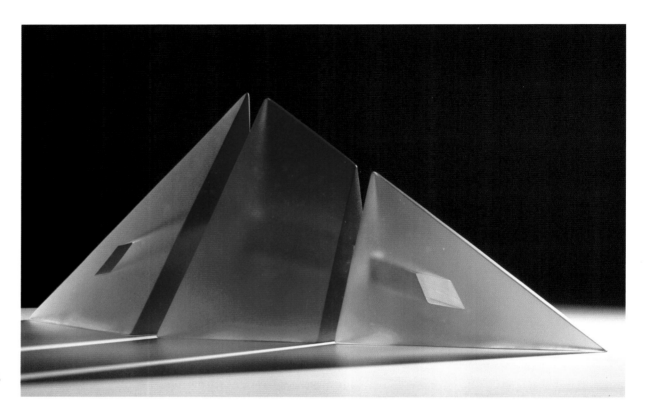

'Passage' (green), 2005

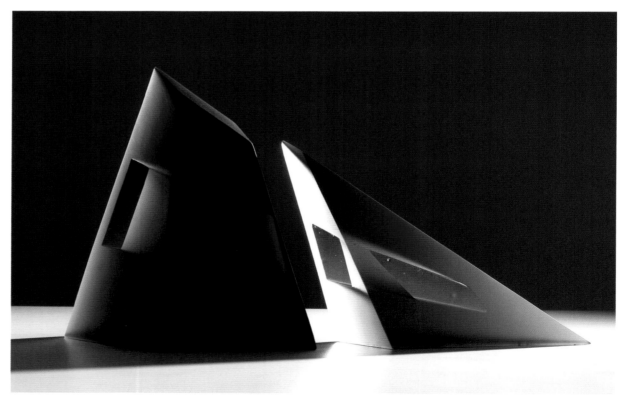

'Passage' (purple), 2005

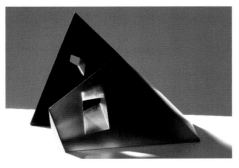

'Cornerstone' (view 1), 2006

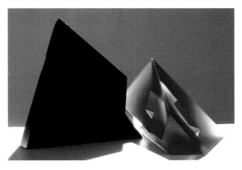

'Cornerstone' (view 2), 2006

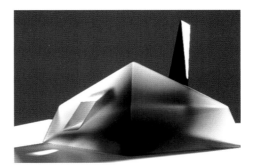

'Cornerstone' (view 3), 2006

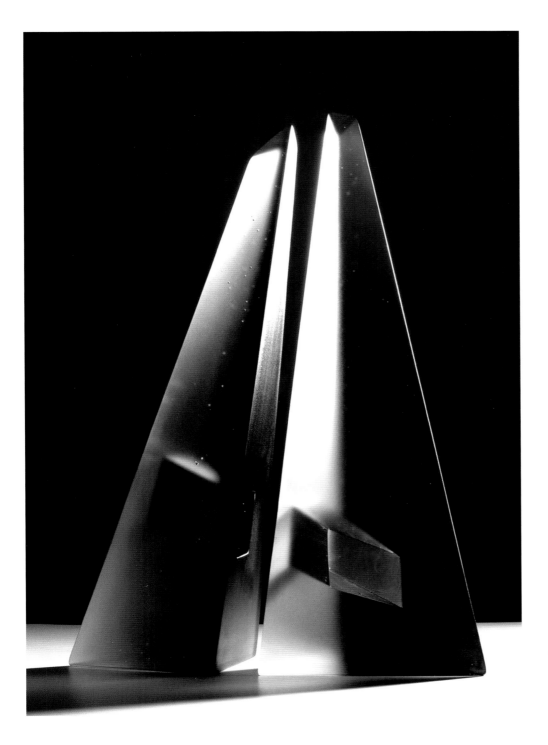

Camden's previous works featured tipping viaducts, gatehouses and towers and explore a 'sense of place,' family ties and genealogy. Recent large life-leaps (motherhood, loss of a parent and a new sense of place) have pushed Camden into new territory. Rather than architectural motifs being points of reference to another place, Camden has utilised the pyramid form to engage in a poignant conversation with grief and the memory of her mother.

'Passage', 2004

Fran Anderton

Fran Anderton, born 1951 and lives in New Zealand, completed a Diploma of Glass Design and Production at Wanganui Ucol in 2003, and now works out of her own studio.

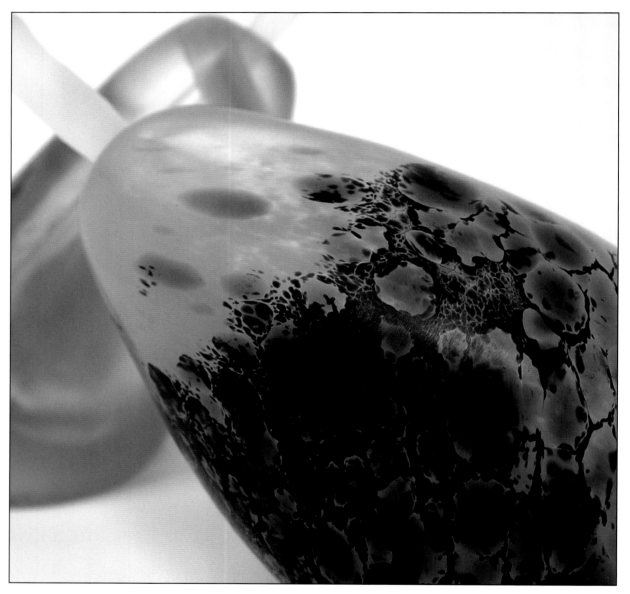

'Avocado', Fruit Series, 2003

Techniques involve the combining of the slow contemplative process in the design and manufacture of cast glass, with the adrenaline rush that comes from working with 'hot glass' in the blowing studio.

The artist's surrounding environment is a major element in the design of her work, with attention being paid to form, colour, and surface preparation. Primary colours are cased in clear glass with the surface being hand worked to a satin finish.

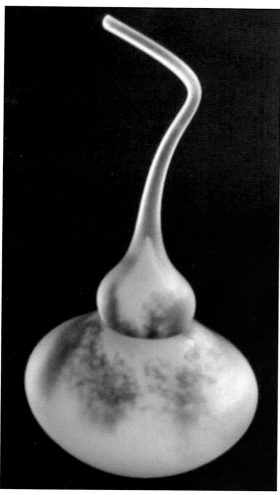

'Kiwi-fruit', 2004

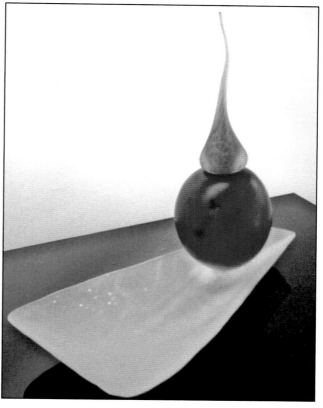

'Tamarillo', 2003

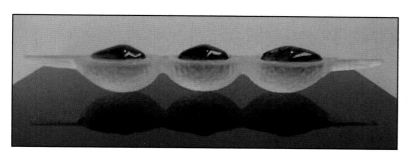

'Pod', 2003

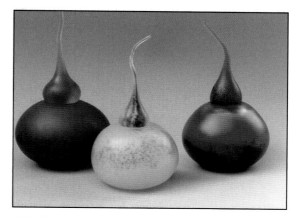

'Olive/Red', *'Lime Green'*, *'Red/Black'*, Fruit Series, 2005

Function is not given priority in the work as she sees it principally as 'Organic Sculpture to be enjoyed by all'.

Jenny Smith

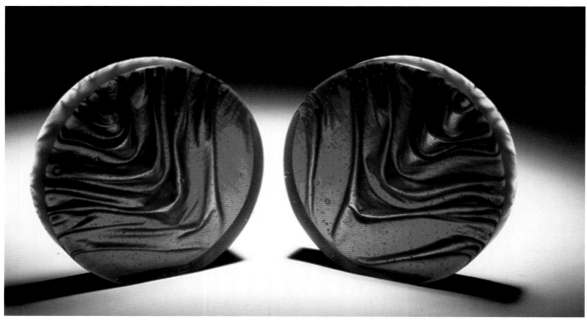

'Ruby Circles', Silk Road Series, 2005

Jenny Smith, born in New Zealand in 1947, is a cast glass artist, drawing inspiration from the textures in our environment, transposing these into glass and comparing, by analogy, to the textures of our lives. Her current series of work is entitled 'Silk Road: Patterns of Time.' Textures, folds and colours of silk are translated into glass to evoke the textures and patterns in our environment. They convey the timeless nature of these ever-recurring patterns and evoke a sense of inevitability.

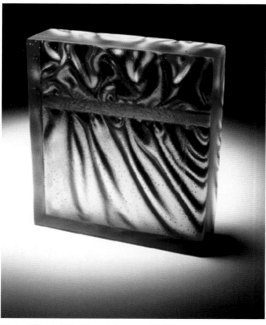

'Pale Olive', Silk Road Series, 2005

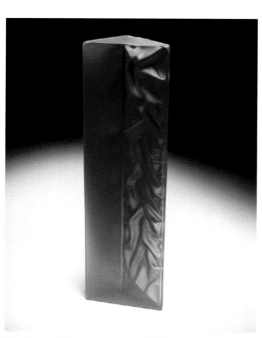

'Semillon', Silk Road Series, 2005

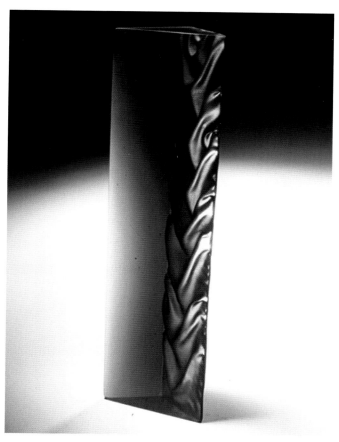

'Bronze', Silk Road Series, 2005

Smith has exhibited in New Zealand, Australia, the United States of America, and Paris. She was a finalist in the prestigious Ranamok Glass Prize 2005, an exhibition which tours Australia for 14 months.

Her current series of work is titled 'Silk Road: Patterns of Time'. Textures, folds and colours of silk are translated into glass to evoke the textures and patterns in our environment. To convey the timelessness of these ever recurring patterns and their sense of inevitability.

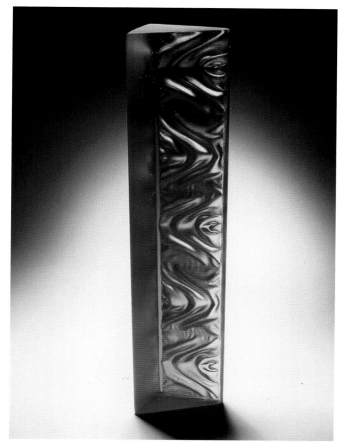

'Semillon', Silk Road Series, 2006

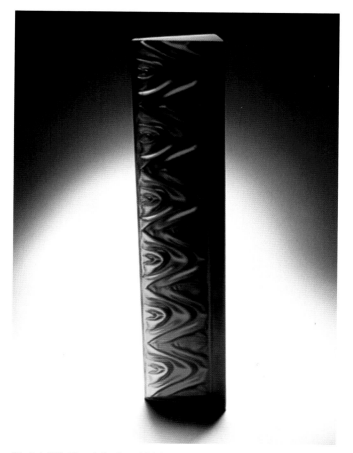

'Ruby', Silk Road Series, 2006

The United Kingdom

Alan Davis

Alan Davis, is a designer-maker of architectural stained glass producing work from his studio on the North Yorkshire coast. Much of his work is ecclesiastical but he also produces private, public, and exhibition pieces. The work is highly influenced by the forms, colours and textures of the environment in which he lives and works.

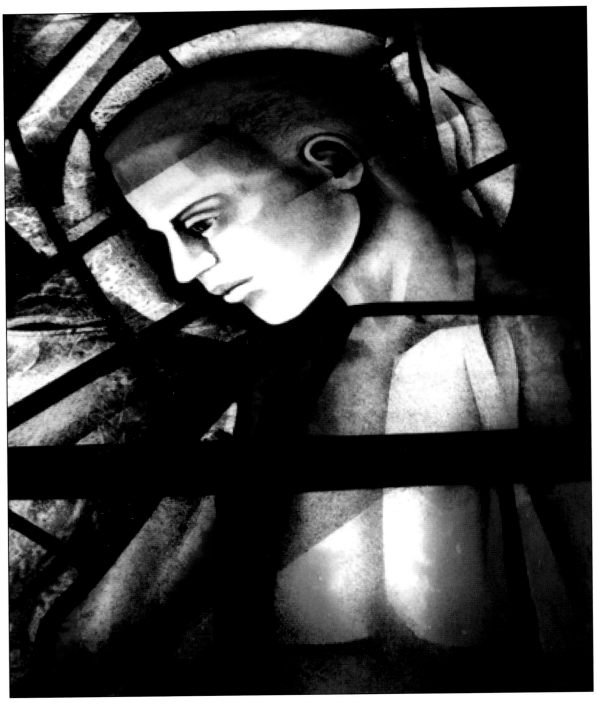

'The Angel and the River of Life' (Detail)

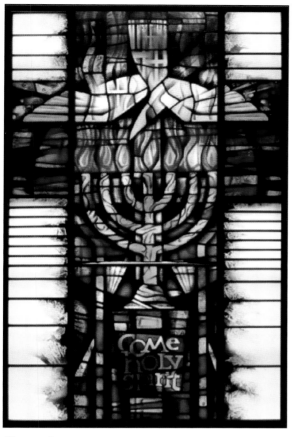

'Pentecost'

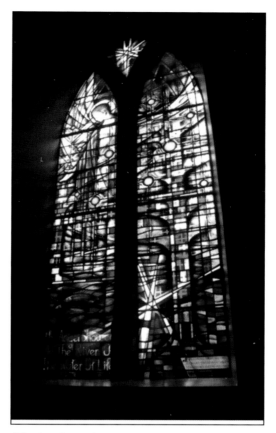

'The Angel and the River of Life'

'September' (Detail)

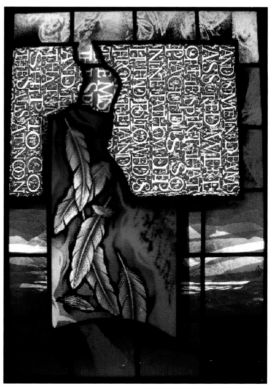

'Mariner'

Bridget Jones

Bridget Jones is an artist working mainly in architectural glass to commission. She has a workshop in the Ouseburn Valley in Newcastle upon Tyne. Born in Glasgow, she studied Zoology at Edinburgh University, and Leicester University, and worked in university teaching and museum education. A degree at Sunderland gave her the opportunity to return to making and creativity, and after graduating in 1988, set up a workshop in Newcastle. In the last five years she has designed large scale work on float glass, screen-printed with fired-on enamels - which can be bent, toughened and laminated.

Spinal Injuries Unit
(detail)

Spinal Injuries Unit

Spinal Injuries Unit

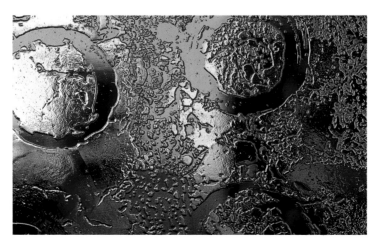

Spinal Injuries Unit (detail)

'Saltwell screen'

'Saltwell screen'

Print and Printmaking have been a lifelong obsession - whether applied to paper, to fabric, or to clay etc. What particularly moves Jones is the evidence in the print of the cutting, carving or etching of the block - that the material becomes part of the mark making, as well as the combination of line, colour and layers.

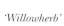

'Saltwell screen'

'Willowherb'

Maingate Desk

Claudia Phipps

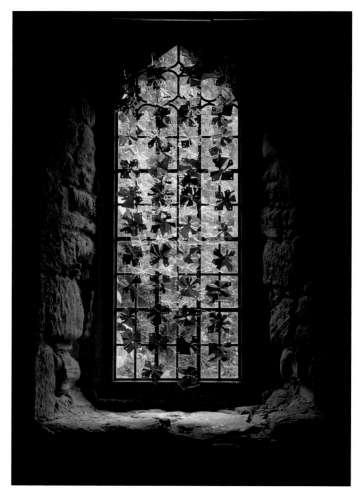

'*St. Francis and the falling church*', 2001

Born in Buckinghamshire, *Claudia Phipps* studied at Sunderland University for her BA and MA degrees, achieving First class honours and distinction. She won the Charles Bray Glass Prize in 2001, and later that year set up her business in Sunderland . For the past year, Phipps has been the Artist in Residence at Eton College where, as well as teaching boys from 13 - 18, she has completed a commission for the Eton College Drawing School. The stained glass incorporates names of boys who will leave the school in the next two years. Entitled "Anonymity", it asks the viewer to consider the significance of a name and what it means to different people.

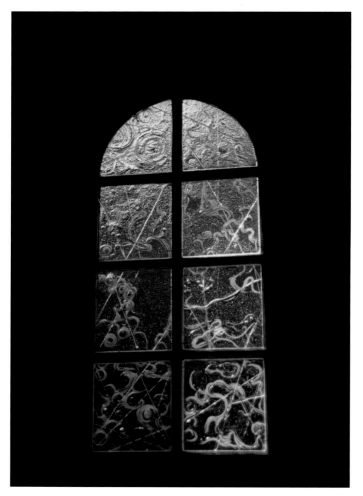

'*Fleur Du Mal*', 2003

'*Study Window*', 2002

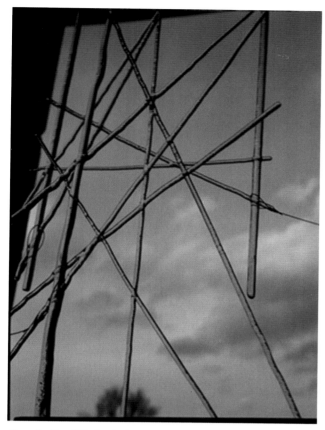

'Serenity Spa Window' (detail), 2002

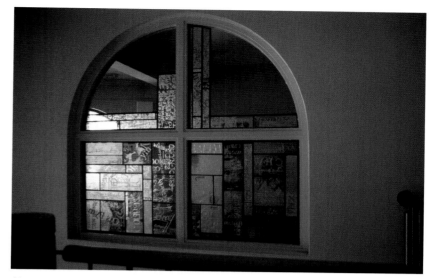

'Anonymity', in the Drawing Schools at Eton College, 2005

Phipps is a designer and maker of Architectural glass. Her work ranges from stained glass to sculptural pieces, and focuses on colour, texture, and the qualities of the material, in particular reflections and fragility. She uses techniques such as engraving and kiln-forming and constantly explores new ideas.

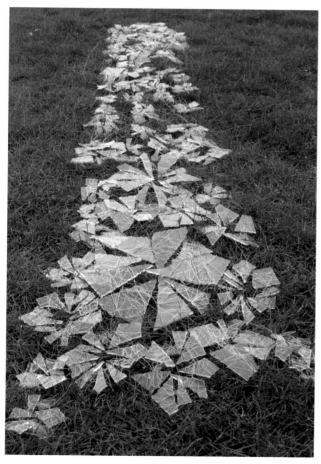

'Spectre', 2003

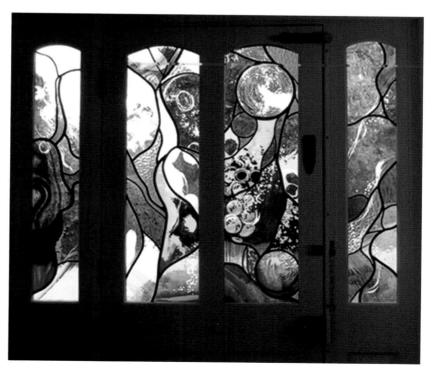

'Dappled Shade', 2004

David Flower

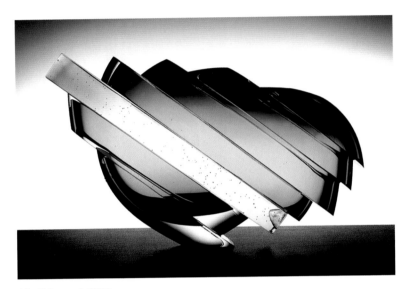

'Gulf Stream', 2005

These pieces were first made as a reaction to the technique - laden atmosphere of a British contemporary glass studio. The pressure to make bowls and vessels is so great that many of our best glass makers spend all of their time on these pursuits rather than following their creative hearts. *David Flower* vessels are designed to be ambiguous and, like any piece of art, purposeless, save for the act of viewing and reflecting.

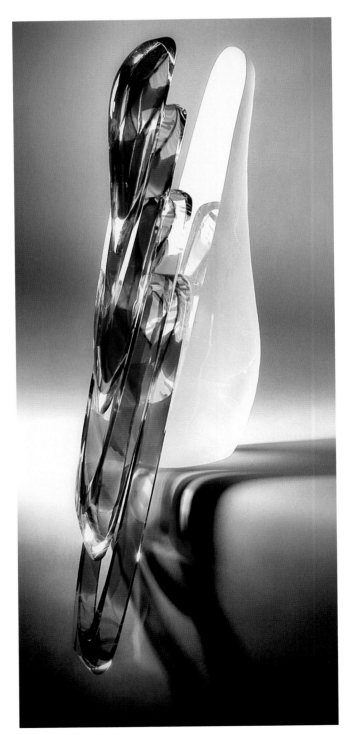

'Postmeridian', 2006

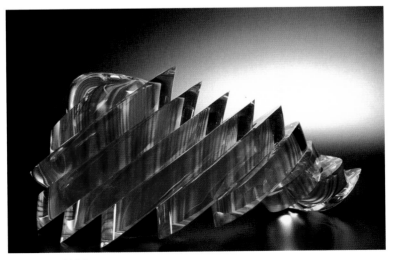

'Vertebrae', 2004

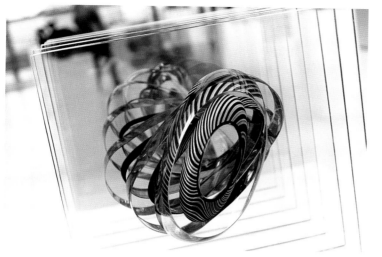

'National Trust Vessel', 2005

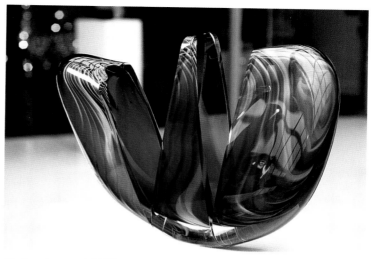

'Broken Autumn', 2005

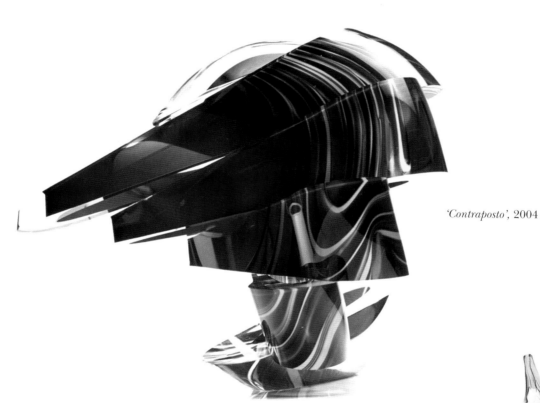

'Contraposto', 2004

Flower received his BA (Hons) degree in Design Glass from Staffordshire University in 1999. After graduation, he started to work as Senior Glassmaker/Designer at the London Glassblowing, which was established by Peter Layton. In 2005, he became an Artist in Residence at the University of Sunderland and National Glass Centre, Sunderland.

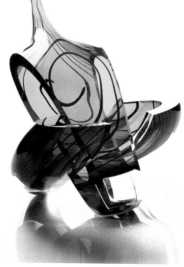

'Reclining Figure', 2004

Davina Kirkpatrick

Davina Kirkpatrick's main areas of artistic experience are in architectural and kiln-formed glass, enamelling and printmaking. Her aesthetic concerns are primarily with the relationship between transparency and opacity (revealing and concealing), line and form, and the overlaying of image and texture to give suggestions of time, history and the complex interactions between her inner self and the outer world.

' Tree Cast'

The tree casts dishes are a continuation of ideas developed for the Cornwall Craft Association Exhibition at Trelissick and Trelowarren in 2004. This was an exterior sculpture exhibition that allowed sculptural forms to interact with the gardens.

The texture of the tree is embedded in the underside of the bowl form giving a tactile and visual close up of a beautiful Cornish tree. The bowl forms are then held with vitreous enamelled copper branches that enable them to be sited at various heights and angles.

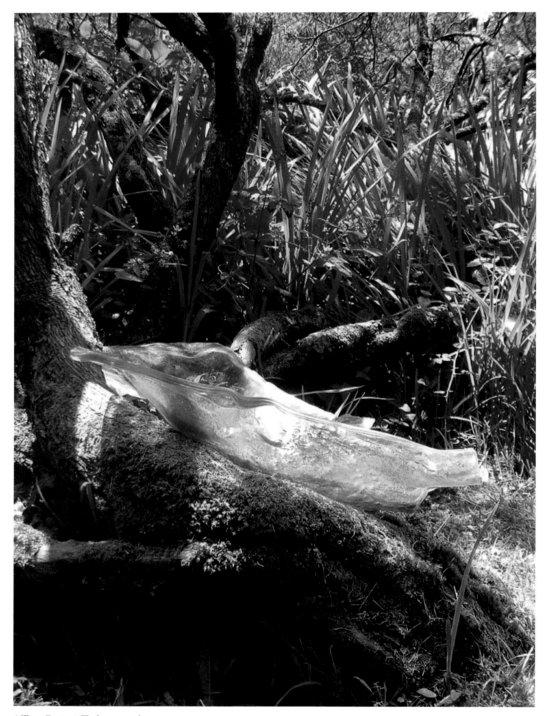
' Tree Cast at Trelowarren'

' Tree Cast'

The artist's involvement with public art, projects and commissions has developed from a fundamental interest in exploring the links between a person and their environment: to what extent does the environment determine the experience of the community, and the alternative view that the environment can be seen to mirror the experience of the community.

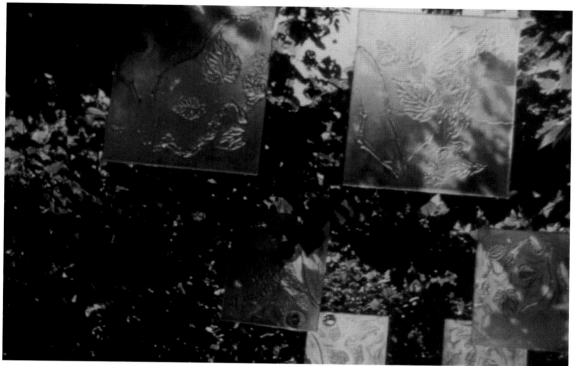

'Marleplace'

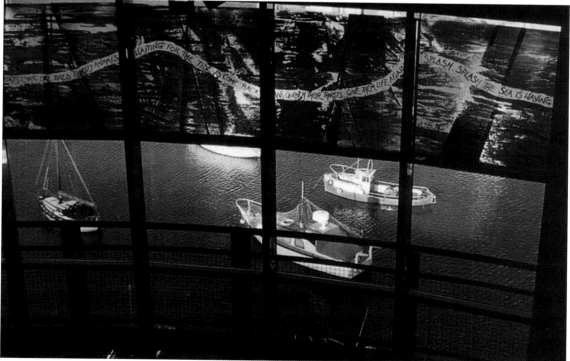

'Beacon-Cumbria'

The Beacon, Whitehaven, Cumbria is a public art project, working with the poet Sara-Jane Arbury and the community to produce poetry and architectural glass.

Deborah Sandersley

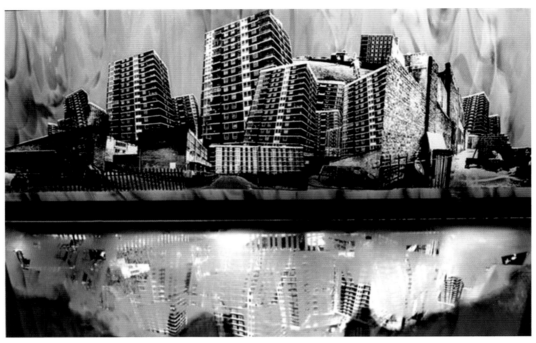

'de beauvoir #1'

Deborah Sandersley spent over ten years working as a freelance portrait/reportage photographer before studying at Central Saint Martin's School of Art and Design where she graduated in Glass and Fine Art and Glass and Architecture. Recent exhibitions include British Glass Bienalle (Stourbridge, Aug. 2004), 'Minus One' New London Glass @ Designersblock (London E1., Sept.2005,) the East London Design Show (Shoreditch EC1, Nov. 2005) and The Windows Gallery (Canary Wharf, Feb. 2006). She was awarded the William De Morgan Travel Award 2002 and the Chase Charity Award in 2003. Sandersley works from her studio near her home in East London.

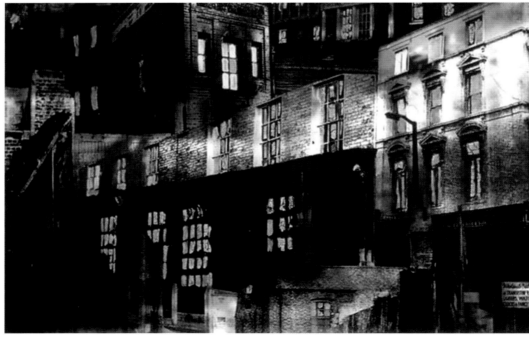

'E1'

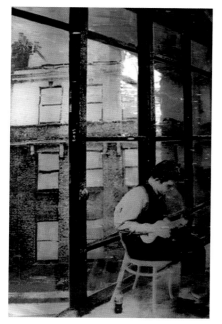

'Hanbury Street'

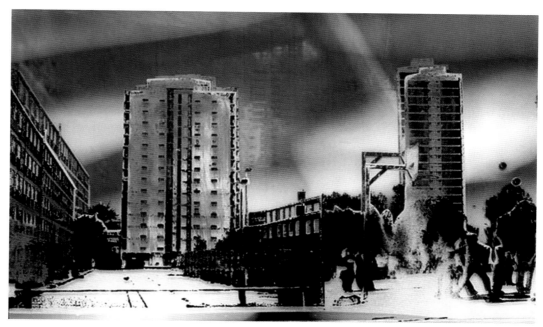

'Brooks'

Her work combines photography and glass, using layering, shading and montage to produce the final pieces. Inspired by day-to-day life, much of her recent work has been based on her photographs documenting the significant change in urban development across East London over the past several years. By focusing on stark buildings and altering the scale or perspective, these areas take on a new form.

The reflective qualities and transparency of glass gives a unique depth and movement to her work that no other material would allow. Lighting, artificial or natural, is also integral in creating a somewhat fantastical representation of what is otherwise an ordinary scene.

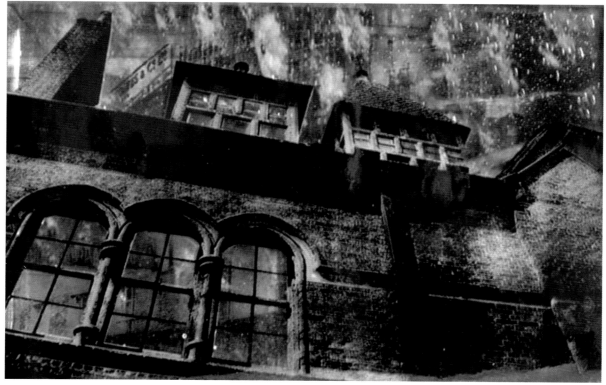

'Apostolic Church'

El Glinoer

El Glinoer lived most of her life in the UK, but also spent some time as a child in Paris, France. She did her A-levels in fine art, photography and print making and a foundation course in art.

Nowadays she works in a glass workshop 'Led & Light' in Camden Town, London. Her recent and first exhibitions in Normandy, France and London have proved her work to be a great success.

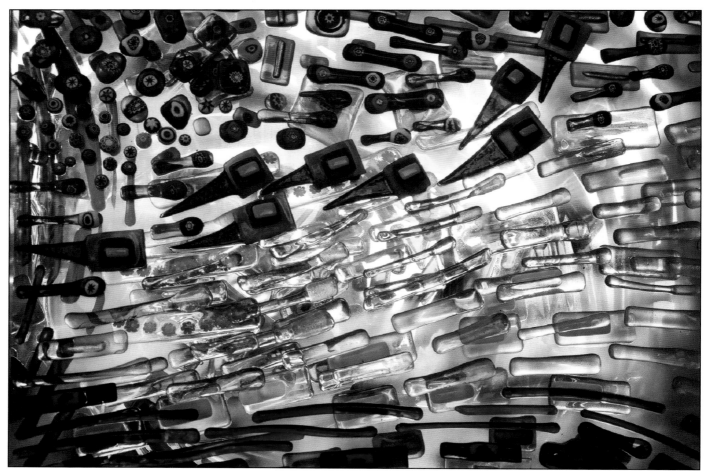

'Strong Seasons' (detail)

El Glinoer's work is made with carefully assembled glass fusions, sweeping forcefully across nine double panels - representing the ultimate power of nature. Millefiori, (the effect of a thousand flowers), and Latticino, (a resemblance of delicate milky lace), both found in Venetian and French paperweights, are the elements she has engaged with in order to create this piece of contemporary glass.

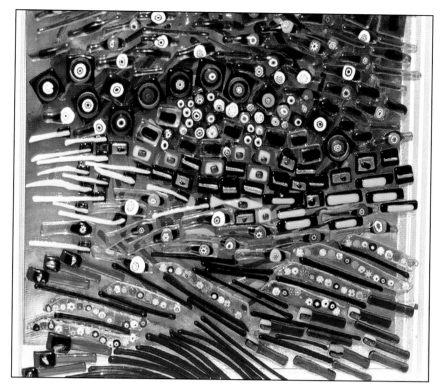

'Floral Waves'

Both her initial experiments and extensive research into 19th Century Classic paperweights, have helped the artist to transpose the essence of their beauty to the modern world.

Light and colours play interesting games between the gaps and spaces in front as well as behind the panels, and the sandblasted areas soften the forms of the fusions.

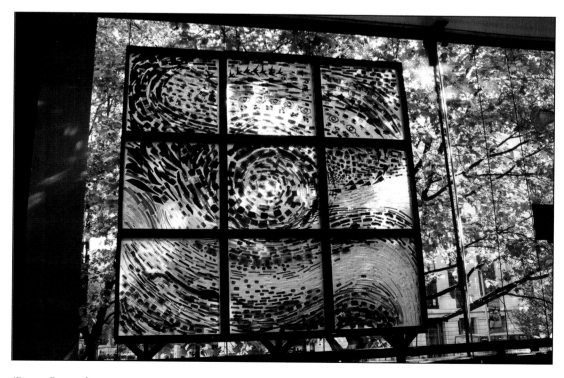

'Strong Seasons'

George Papadoploulos

Unlike most artists working in glass, *George Papadopoulos* treats his medium with a healthy disrespect. Using a technique he developed at the Royal College of Art, Papadopoulos breaks, colours and textures sheets of industrial glass and then re-laminates them to make architectural-scale artworks that look fragile but are extremely durable. These works express the in-built paradoxes of glass: that it is commonplace and extraordinary, visible and invisible, dangerous and strong.

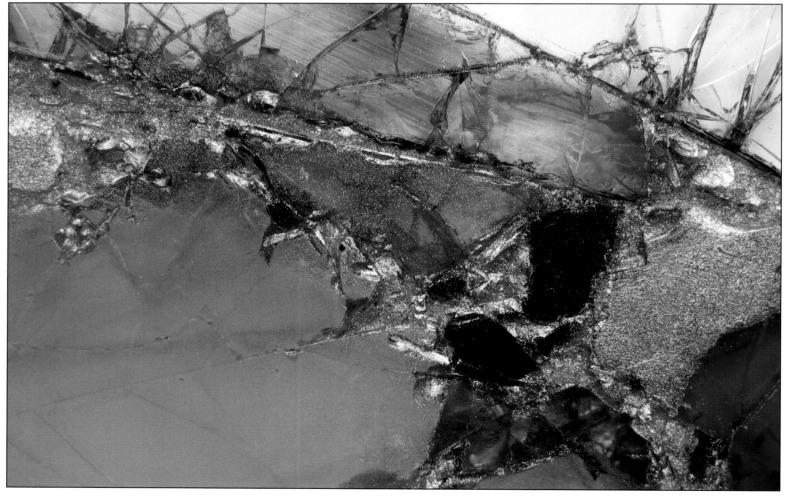

'Gold' (detail)

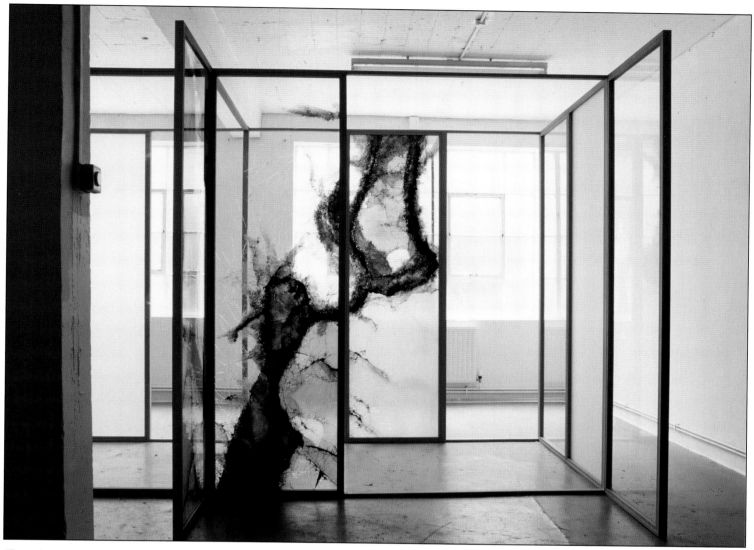

'Grove '

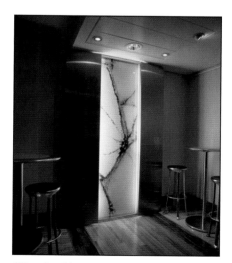

'Blue Crack' at BA Terrace Lounge, London
Heathrow Airport, Terminal 4, 2000

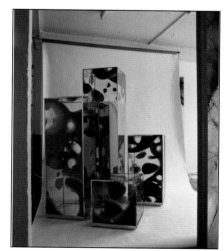

'Elais'

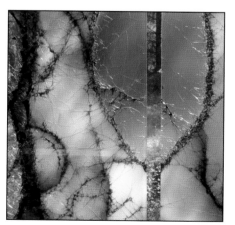

'Pool'

Gill Hobson

Gill Hobson's jewel-like pieces have a richness and intricacy seldom seen in contemporary artworks and sculpture. Her work is primarily concerned with the interaction of complex pattern with form, often combined with primitive symbolism to create pieces that are both intriguing and inspiring. Hobson works at a variety of scales from fine jewellery & table top through to architectural & large scale exterior sculptural pieces which have featured in award winning schemes. Balance and harmony are integral to her work and each piece is expressed in Hobson's signature style of delicate wirework set with individually formed glass cabochons.

'Squiggle'

'Fluid Forme'

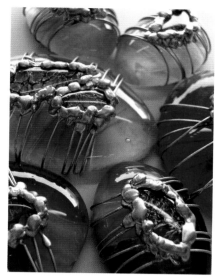

'Blue Jewelstones'

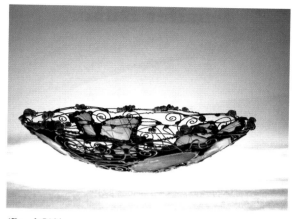

'Royal Gift'

'Blue Spiral'

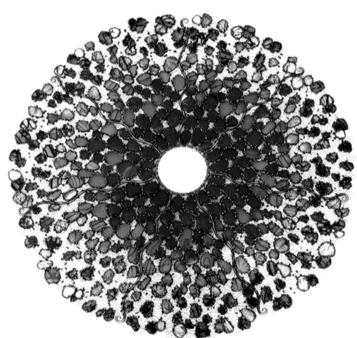

'Deep Blue Meridian'

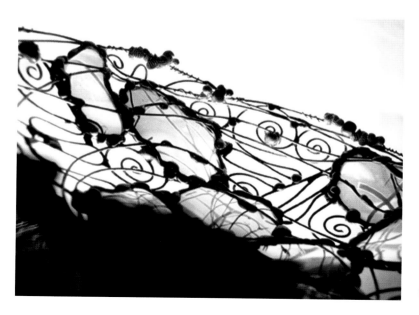

'Royal Gift'
(detail)

'Deep Blue Meridian'
(detail)

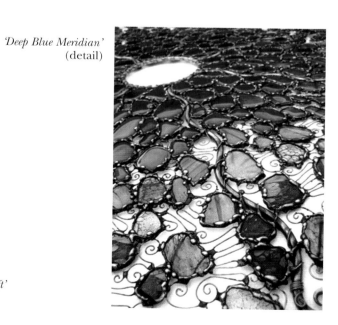

Jennifer Barker

Jennifer Barker graduated from Wolverhampton University with a degree in 3-Dimensional Glass Design in 1993, where she specialised in hot glass before focusing her attentions to kiln-fused glass through further studies at Staffordshire University. Since then she has developed her own business, Melt Designs, based in Liverpool that specialises in bespoke glass solutions for both architectural and interior design applications.

Backlit glass panel, 2005

Series of backlit glass panels for conservatory. Coloured-fusible glass on white-flashed opal, 2005

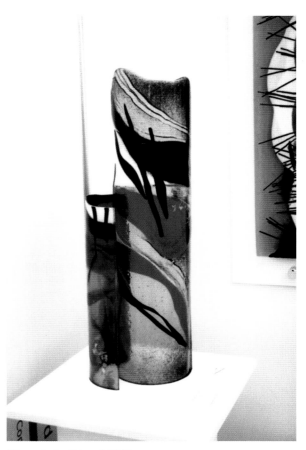

'Organic Sculptures', 2005

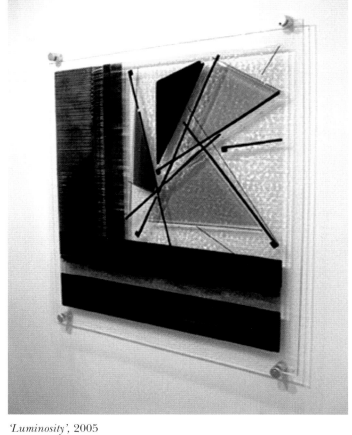

'Luminosity', 2005

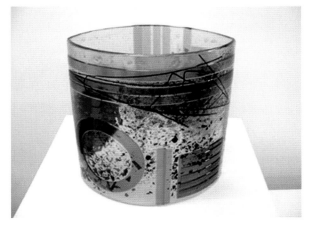

'Sculptural Vessel', 2005

Over the last decade, Barker has been working on projects as diverse as multi-layered windows for airports, wall art for bars, restaurants and hotels, nightclub chandeliers and lighting features for television sets. This is in addition to developing collections of work with a distinct geometric design element that has become Barker's signature.

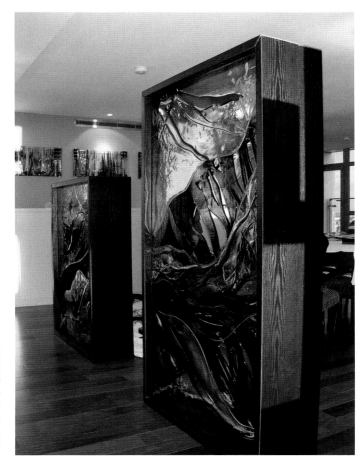

2 multi-layered glass dividing screens mounted in a black oak frame - penthouse apartment, Liverpool, 2005

Jazzy Lily Hot Glass – Pauline Holt

'Jazzy Lily was a name I heard someone use to describe a person wearing bright and colourful clothes.'

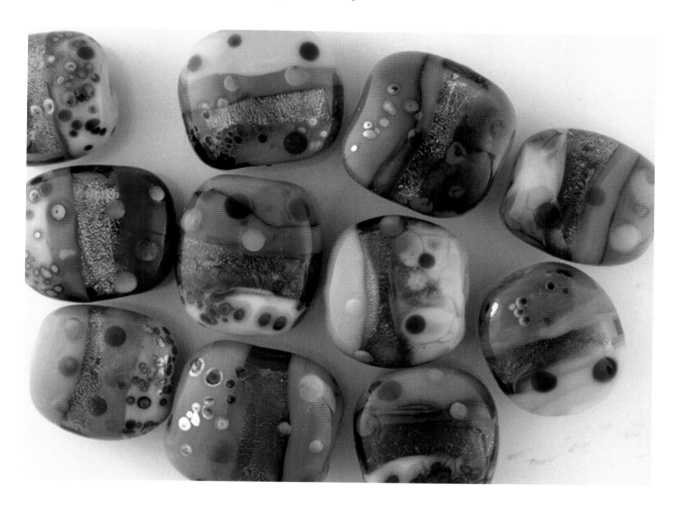

'Bright Beads'

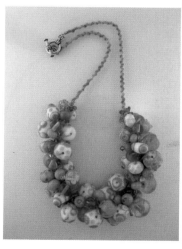

'Coastline' (on the left)

'Flower Necklace' (on the right)

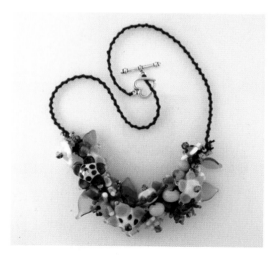

Pauline Holt has always been excited by colour, and especially coloured glass. Even before her glass bead making course in 1998, she knew that she had found her ultimate passion. The sheer challenge of heating glass and shaping it into miniature works of art that can be worn, she still finds somewhat magical. During 2001, Holt began teaching the art of bead making for beginners, and now regularly teaches at Plowden and Thomson's in Stourbridge, West Midlands.

Joanne Mitchell

Joanne Mitchell gained a first-class degree in 3-D Design from Manchester Metropolitan University, specialising in hot glass and metalwork. Following her degree she won a scholarship for a Masters in Glass Product Design with the University of Wolverhampton, in collaboration with the Edinburgh Crystal Glass Company, which allowed a free reign within the factory's production facilities to exploit and challenge the boundaries of crystal manufacture and design. On completion of her Masters degree she worked for Edinburgh Crystal as an in-house designer, until 2003 when she founded Joanne Mitchell Glass Design, creating her own range of studio glass designs in repeatable and one-off pieces.

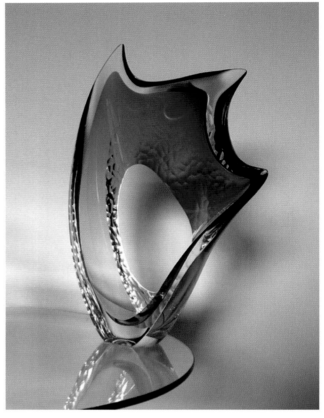

'Dancer'

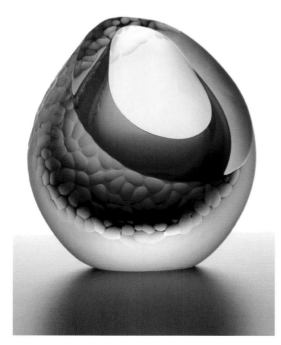

'Blue Void'

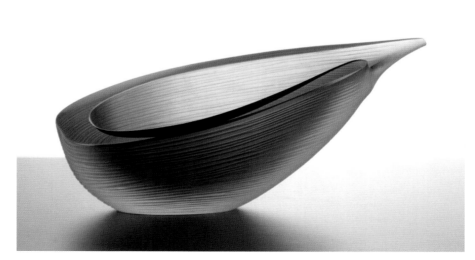

'Void' (detail)

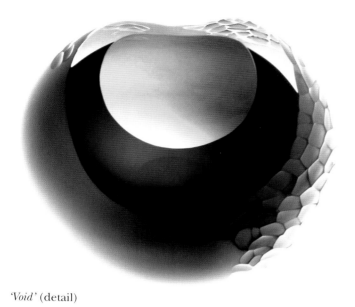

'Void' (detail)

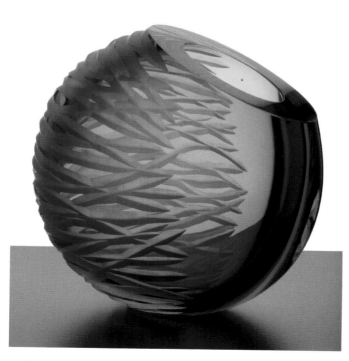

'Peri' vessel

Mitchell has developed a beautiful range of one-off or limited edition glass vessels that combine blown and wheel cut glass. They go beyond function to express the inherent qualities of the material and their production.

'The development of a piece can be led by an exploration into the flow of glass under pressure, the balance of form and texture, or of distortion and refraction within a solid clear mass' explains Mitchell, 'This sensual element is distilled from the irregularity and diversity of natural forms: the landscape, the human body, or some significant aspect of one of these.'

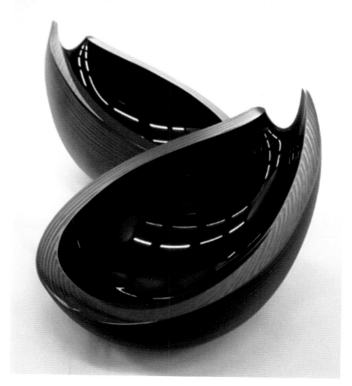

'Oblique' vessel

'Breeze' Bowls

Louisa Gillie

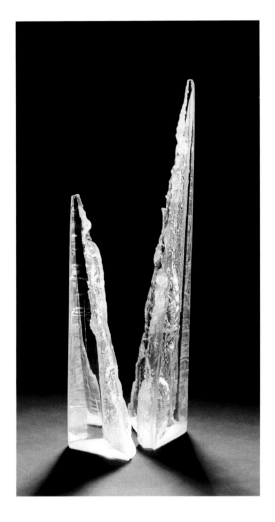

It is the material itself that inspires *Louisa Gillie* the most, the inherent qualities and incredible contrasts that glass holds; transparent or opaque, rough and sharp or smooth and highly polished, heavy and dense versus fine, fragile and delicate. She aims to use these contradictory traits in her work to create visually stimulating pieces by juxtaposing texture, inspired by found natural forms such as bark or rocks, with highly polished reflective surfaces. Gillie purposely uses combinations of curved and flat faces to create reflections and constantly changing optics as you move around the piece or look from different angles. She is also interested in the internal space: the contrast between perfectly clear glass using just one or two pieces when firing, to using many more pieces which create veils, bubbles and a completely different yet intriguing fourth dimension.

'Barking Pair'

'Enigma'

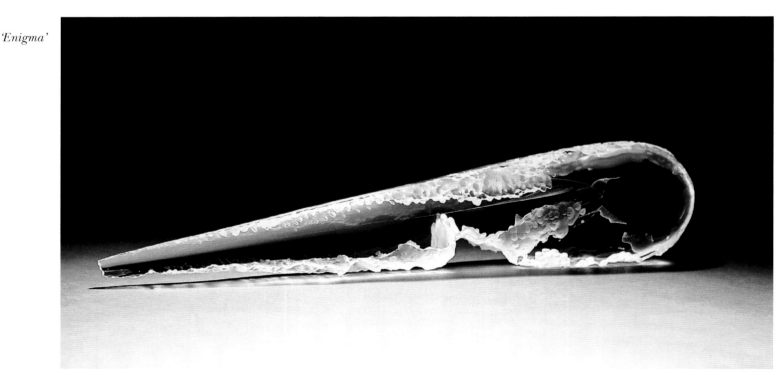

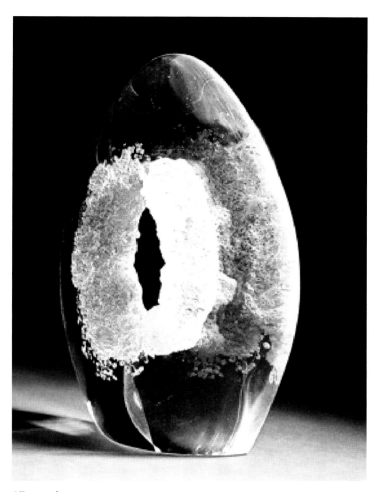

'Cosmos'

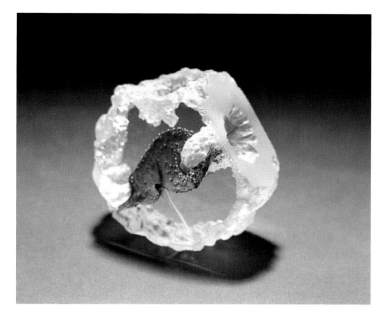

'Rockies' (purple)

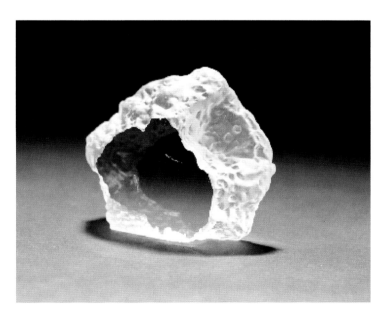

'Rockies'

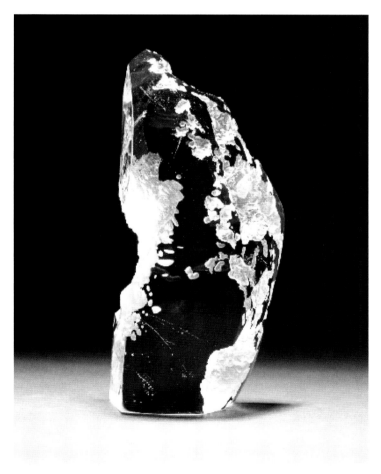

'Labyrinth'

Gillie's biggest inspiration comes as she works on a piece. She draws designs very quickly then develops these in three-dimensional models. She then kiln casts the glass and nearly always makes changes when the piece is in glass: cutting pieces up, taking sections out, adding more texture etc, before highly polishing the surfaces using hand held air tools. Nothing is ever straightforward with glass and it is this unpredictability that she loves. She never quite knows how a piece will look until it is totally finished. The titles of many of the pieces often refer to the journey it has taken from drawing and original idea to finished piece.

Lucy Wade

In 1997, *Lucy Wade* gained her BA (hons) in Design and Applied Art (Glass) at Edinburgh College of Art. Five years later she received her MA in Ceramics and Glass from the Royal College of Art, London. She was shortlisted for several awards and is the winner of the Worshipful Company of Glass Sellers Student Award 1998. Her works can be seen at exhibitions around the UK.

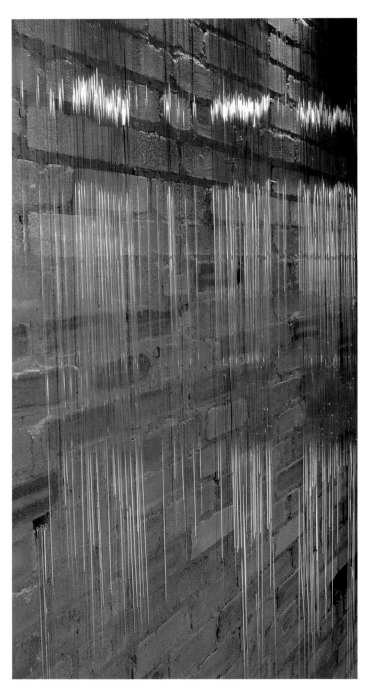

'Lines' (detail), British Glass Biennale, 2004

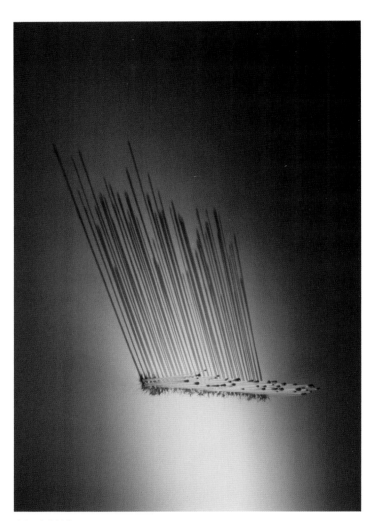

'Now', 2002

Growing up on the Isle of Wight she spent a lot of time drawing waves, trying to capture the energy and spontaneity of the water. This brought about an awareness of repetition within movement, time and sound.

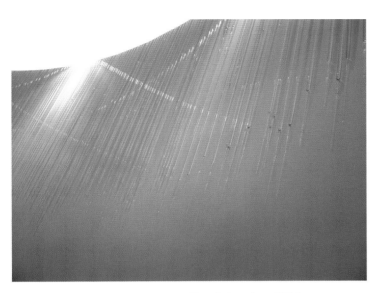

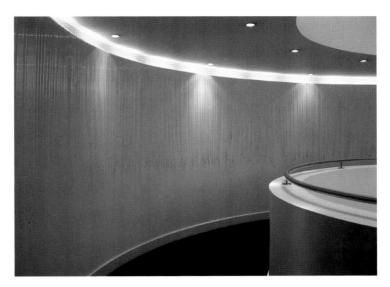

'300 Lines' (detail), Great Eastern Hotel, London, 2003

'300 Lines', Great Eastern Hotel, London, 2003

Wade consciously uses appropriate processes to articulate language and to communicate a particular sensation or feature derived from the nature of the material. The artist weaves in the possibility for change by working in a loose or modular way as such the composition is often defined as much by timing and conditions as by intention.

'Lines', West Dean College, Chichester, 2005

Penelope Somerville, M.A.

Penelope Somerville was educated at Clwyd College of Art and Technology, Manchester University and Chelsea School of Art and Design. She has an HND in Applied Art and Design specializing in Architectural Glass and an MA in Public Art. She was Programme Leader for the Architectural Glass department at the North Wales School of Art and Design in Wrexham, and also Principal Lecturer and Course Leader for the BA and MA degree courses in Contemporary Applied Arts. She is a Freeman of the Worshipful Company of Glaziers and a Fellow of the Royal Society of Arts. She has exhibited both glass and paintings in Wales, England, London and Italy. She now lives and works as a painter and glass artist in Devon.

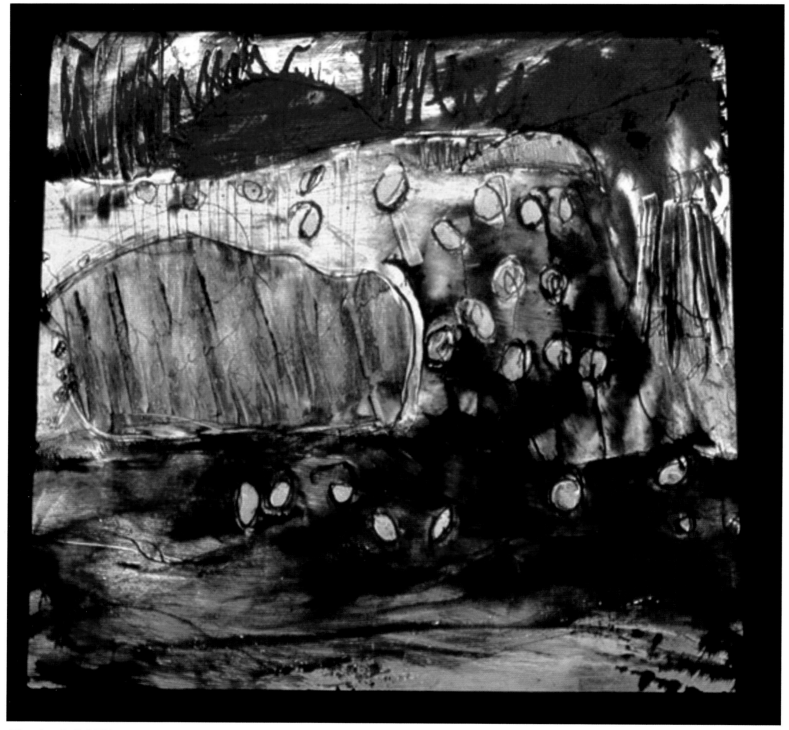

'Heat drenched', 2005

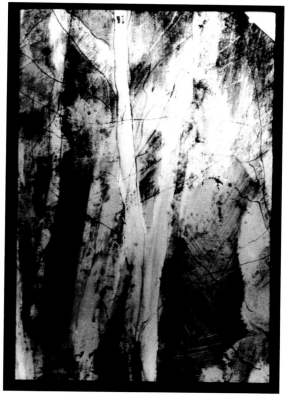

'Pilcuhcuk', 1999

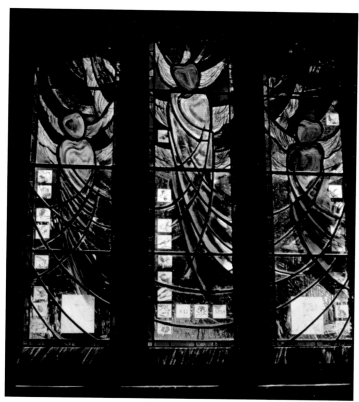

'St. Mary's Bruera', 2000

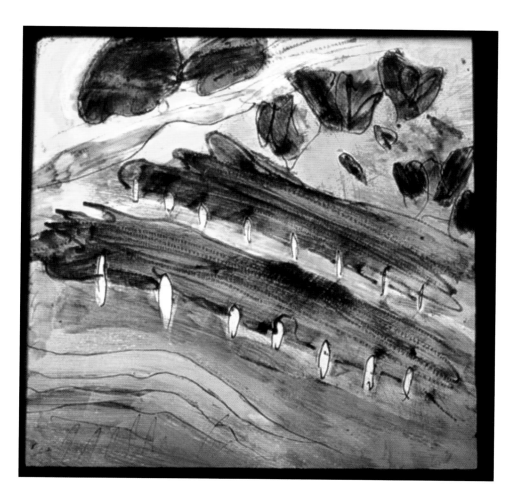

Somerville responds to the spirit of the landscape, making sketches on the spot using a variety of media. She is especially interested in the meeting of land and sky. Her sketches are then developed into full scale paintings. These images are translated onto enamelled and engraved glass panels, drawing on the skills and resources of the glass craftsman and are intended to convey a sense of depth, gesture and luminous colour. The enamels are fired many times to achieve a sense of depth and layering.

'Verrochio Fields', 2005

Peter Layton

Born in Prague and brought up in England, *Peter Layton* studied ceramics at the Central School of Art and Design in London under some of the foremost potters of the day. He chanced upon glassblowing while teaching ceramics at the University of Iowa and since returning to Britain has been continuously at the forefront in promoting this magical and versatile medium. In 1976, he established the London Glassblowing Workshop in an old towage works on the Thames at Rotherhithe.

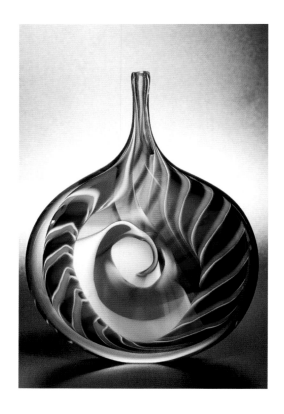

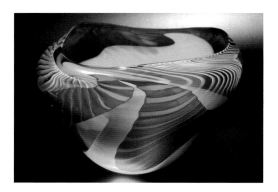

Following the demise of British Artists in Glass, Layton initiated the now thriving Contemporary Glass Society (CGS), becoming its first chairperson. In 2003 he was awarded honorary life membership of CGS.

In December 2003 he was awarded an Honorary Doctorate of Letters by the University of Bradford, in recognition of his major contribution in the Arts& Crafts.

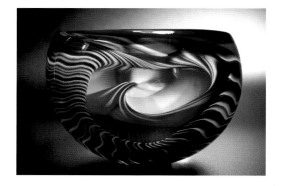

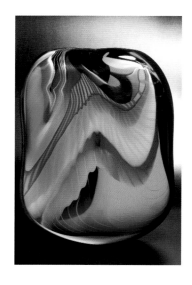

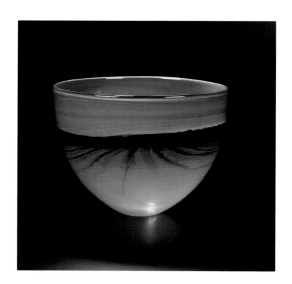

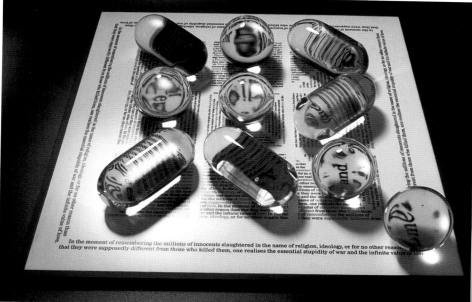

'The Game of Life'
This installation comments on society's drive towards disintegration, and the precarious nature of life.

Layton originally trained in ceramics, but the discovery of hot glass was the beginning of a new love affair. He was inspired by the immediacy of this enchanting and elusive medium, as much by the demanding process and the magical and exquisite material. Each piece presents an adventure and a challenge to control form and colour, whilst allowing the fluidity of the glass to contribute its own qualities and characteristics. Self taught as a glassmaker, Layton's work is organic and tactile, striving to achieve a form of controlled asymmetry.

'Battery'
is a part of a series entitled "Matters of the Heart" , and stems from the insight that between birth and death there are only precious present moments encompassing love, joy, passion, strength, courage, wisdom, humour, generosity, creativity, freedom-and of course, their opposites. In squandering these we are obliged to live with the consequences.

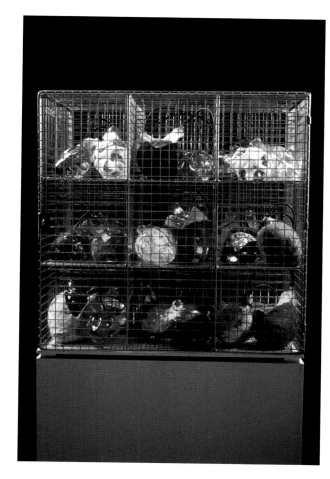

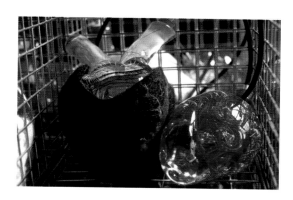

Rachel Elliott

Born in Kingston upon Thames, England, in 1982. Originally coming from a background in stained glass, Rachel Elliott had formal training in a wide range of both hot and cold glass techniques which now means that her work bridges many of the varying disciplines. She abandoned the functional route to utilise the properties of the material in an expressive way, exploring various themes of modern identity. Her work sometimes incorporates iconographic or instantly recognisable images from everyday life with the view to bring both humour and viewer association into the work.

'Cow tornado'

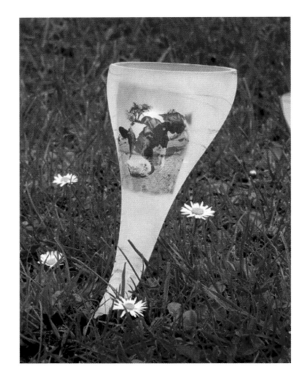

'Tornados' - 2004, various sizes up to 25cms tall, blown & engraved lead crystal.

An outdoor installation of 13 glass tornados, each uniquely engraved using diamond wheels or sandblasting. The pieces were made to represent and express the all encompassing forces that exist in nature which can rampage across the manmade world with little resistance.

'Warning: Hazardous To Your Health' - 2006, 23 x 23 x 10cms, screenprinted & kilnformed float glass.

The glass jelly on it's doily adorned plate is at first glance an innocent and playful object. On second inspection it's 'hazardous' surface of toxic signs and irregular colouring indicate its underlying and sinister nature. The piece is a comment on the potentially dangerous situations glass artists put themselves in for the love of working with the material.

'Hazardous' (top)

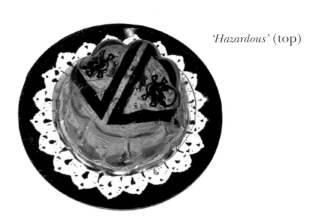

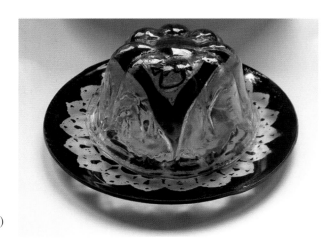

'Hazardous' (front)

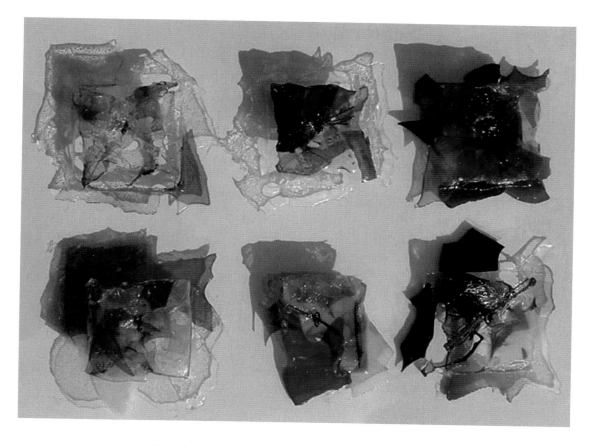
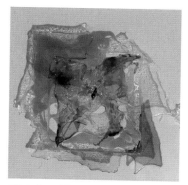

'Rainforest' Detail

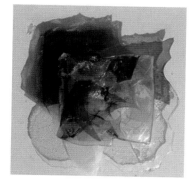

'Under Sea' Detail

'Belly Button Boxes' - 2004, 43 x 57 x 10cms, kiln-formed lead crystal with metal inclusions
6 fused components, each in the form of the female navel representing the maternal line. The navels are all pierced, adding a contemporary twist and constructed in a broad palette of colours to represent different imagery. The fragility of all the components plays an important role in conveying the shells that we place ourselves and our emotions inside as well as linking with their given themes.

'Birthday Blues'

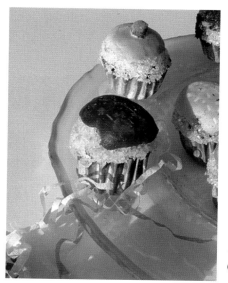

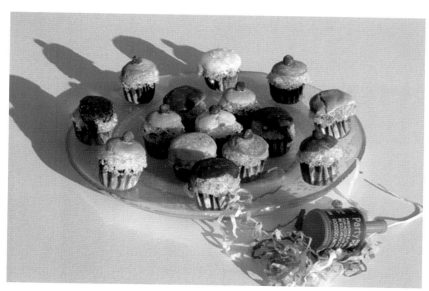

'Birthday Blues' (detail)

'Birthday Blues' - 2005, 25 x 25 x 8cms, Pâte de Verre soda glass & copper.
The cakes in this piece, are miniaturised (each no more than 4cms tall), made from copper and glass, taking on a crystallised and inedible appearance, hinting at something more stagnant and ominous. Each cake captures a moment of childhood innocence and excitement from an adult and slightly cynical perspective.
The cakes are placed on a glass plate with a doily design sandblasted on the surface.

This piece was awarded Second Place in the Warm Glass Prize 2005.

Selina Radford

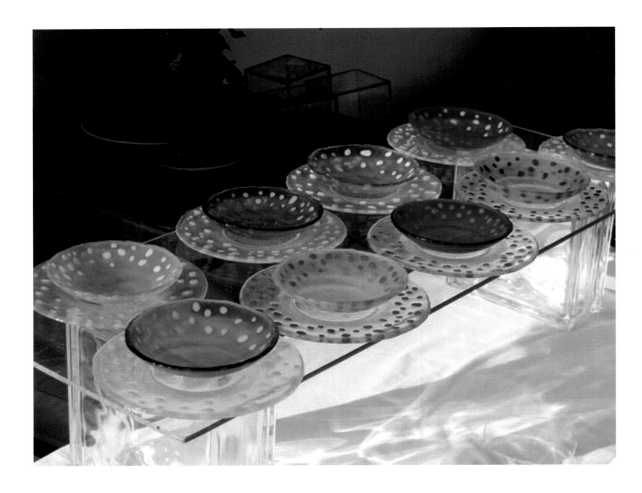

Selina Raford has lived in Cornwall since 1969, graduating from Falmouth College of Art and Design with a BA (Hons) degree in Fine Art in 1999. Her work during her degree was in Sculpture, Photography and Printmaking. Glass was one of a number of media Radford worked with and has since become her preferred medium.

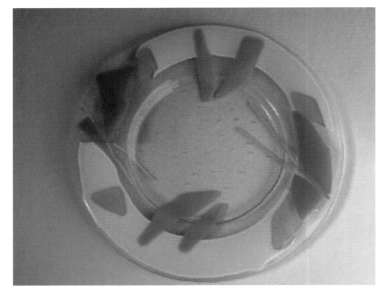

'Briar Cottage Blossom'

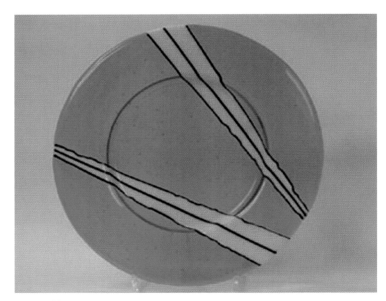

'Waspish'

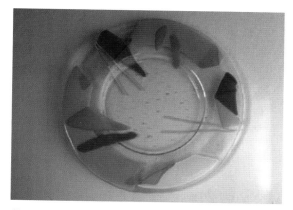

'Briar Cottage Blossom'

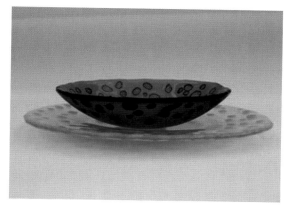

'Weenie-TURQUOISE 1-Spottie turquoise'

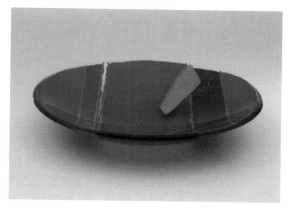

'Tomatoe Salad Rocker'

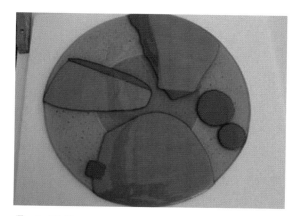

'Fruity Disk'

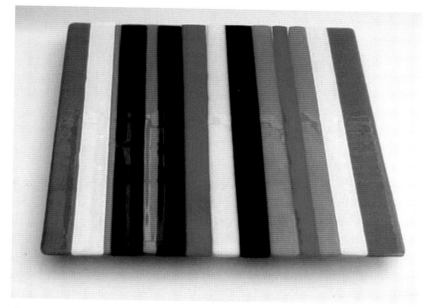

'Urban Lights'

During 2002/03 Radford spent a period of 4 months in Morocco. The vibrant colours and strong geometric design have evolved in direct response to this life-changing experience.

The artist sees her current work as functional, contemporary objects that make a fashionable design statement. Functional work and 3D objects are in private collections and have been exhibited in Cornwall and Hampshire. Radford welcomes the opportunity of working to commission.

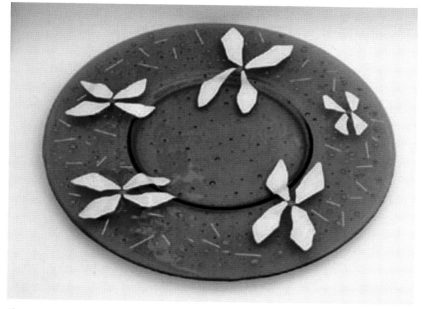

'Spring Meadow Platter'

Sophie Lister Hussein

Sophie Hussein has an open and organic approach to glass design, and takes on each commission with enthusiasm. This often means that she adapts her design methods according to the demands of the brief. Those that allow the freedom to use a range of methods within the one piece – which can include acid etching, sand blasting, glass painting, fusing, etc, along with the more traditional methods of glazing and leading – often the most rewarding and challenging to work on.

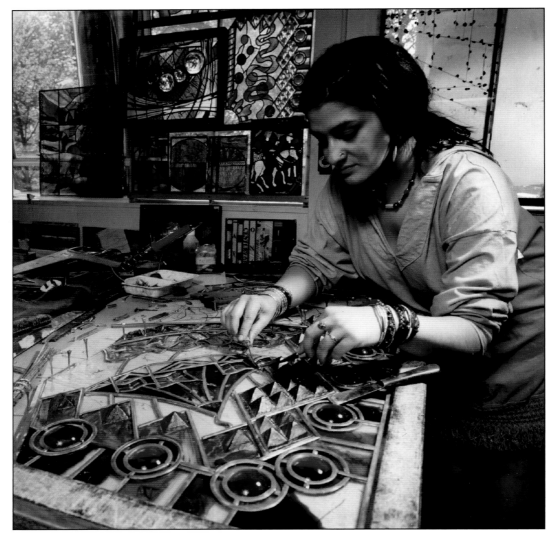

The Artist

As an artist, she finds that the designs that engage her the most are those that allow expression of a powerful and energizing dynamic, and she enjoys pushing the limitations of glass; challenging the accepted conventions / traditions of the material. Hussein has also worked in more traditional ways, on a number of heritage restoration pieces for large conservation clients; including English Heritage - restoration projects that covered English, French and Swiss medieval windows, and The National Trust - restoration of the leading in a Georgian Stately Home at Dunham Massey.

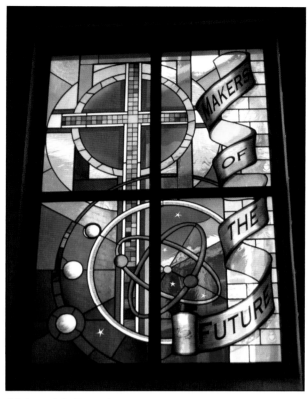

'Makers of the Future'

The artist uses glass as if it were a canvas, and with a confident technical understanding, she believes that marks and colours can be applied innovatively, and pictures can be painted that fulfil emotional and aesthetical needs – showing an explicit sensitivity. Although glass is seen as having hard and sharp surfaces, it can express a fluidity and delicacy as fabrics like silk.

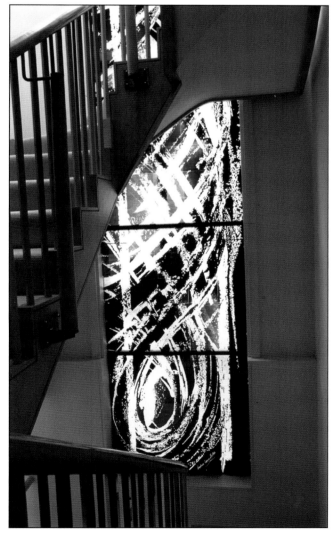

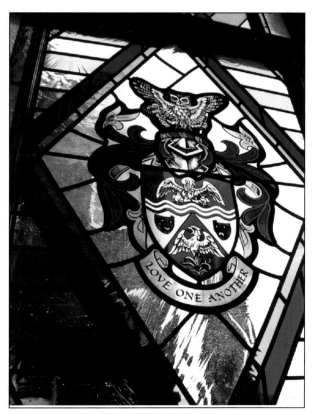

'Love One Another',

'Stairs Abstract'

Stuart Garfoot

Stuart Garfoot has always been fascinated by the rich, abundant, colourful, natural life forms found under the sea on coral reefs. These complex, animated, bold, liquid creatures are held together in an almost spiritual dance of communication and mutual survival. They are at once dynamic and independent single life forms, unique and wonderfully individual, yet completely interdependent in 'family' groups, life flowing one into the other. Frozen in a moment they are caught in all their imaginary, fluid and graceful beauty. He works in a mix of glass making techniques which reflects his visual language as a glass artist and designer. He translates the colours, forms and textures from the reefs through blowing and centrifugally casting glass into individually hand formed objects where nothing can be repeated more than once, capturing light, movement and colour.

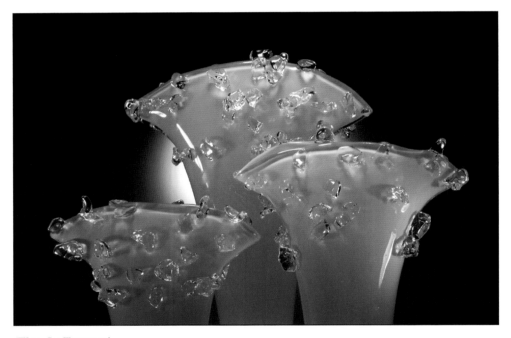

'Three Ice Trumpets'

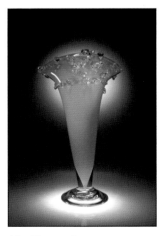

' Ice Trumpet'

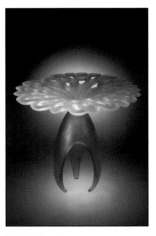

'Radar Love'

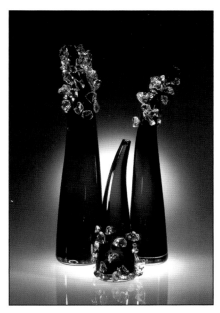

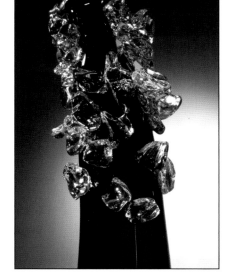

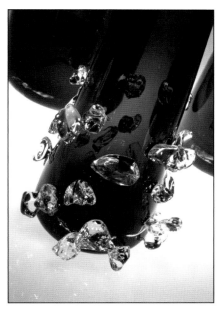

'Ice Chi'

'Ice Chi' (detail)

'Ice Chi' (detail)

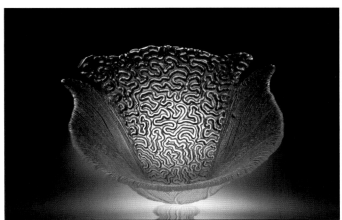

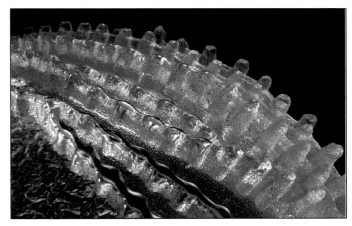

'Brain Wave'

'Strata' (detail)

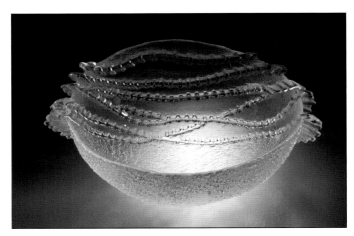

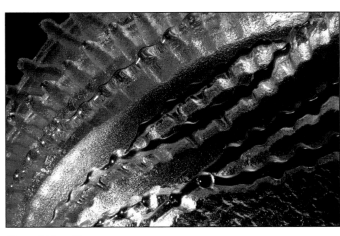

'Strata'

'Strata' (detail)

Tillie Burden

Tillie Burden is a glass artist living and working in London. She completed hot-glass training in her native Australia, at Monash University, and since graduating has travelled to various glass blowing studios in the world to gain experience and expand her skills. Burden enjoys the feeling of community and friendship within the glass art world. She finds the artists incredibly generous of their time and skill and she is continually in awe at the capabilities of glass, and the degree which individuals stretch these boundaries to.

'Inward'

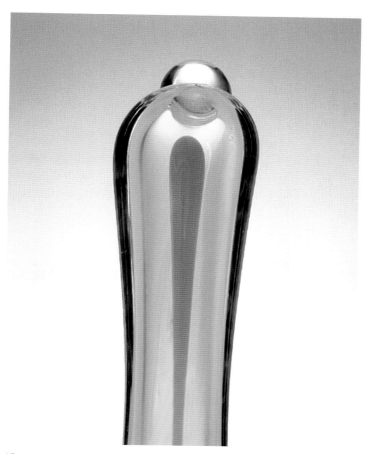

'Gemini'

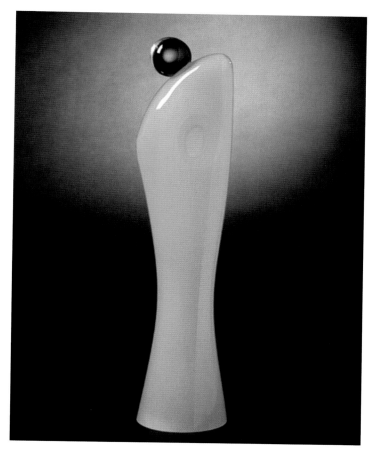

'Reveal'

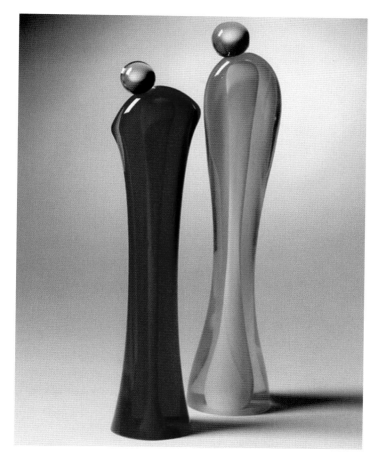

'Interior Motive'

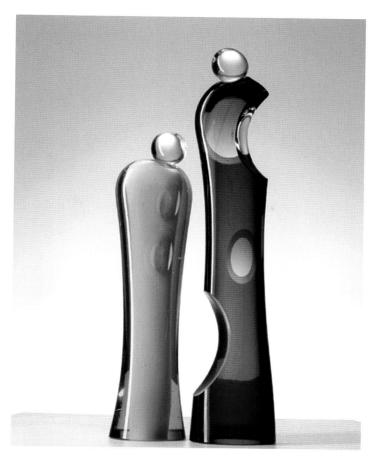

'Pursuit'

Timothy Harris

'Graal'

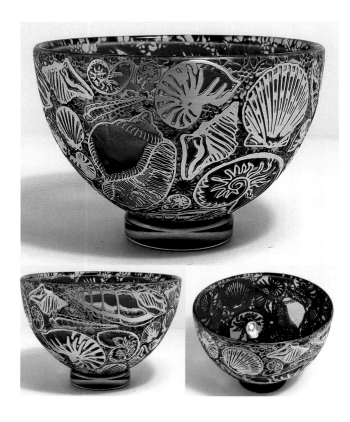

Timothy Harris was born 1961, eldest son of Michael Harris (1933-1994), international Glass Designer/Maker, founder of Medina & Isle of Wight Studio Glass, where Timothy Harris began his apprenticeship in the glass world.

Now as Managing Director of Isle of Wight Studio Glass, he has been involved in launching many studios worldwide, after gaining experience in the UK, USA, Malta.

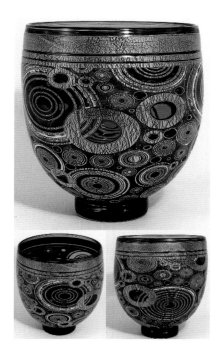

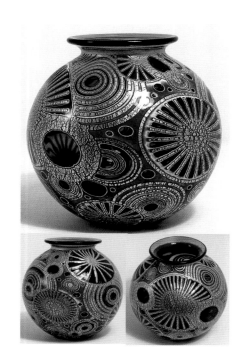

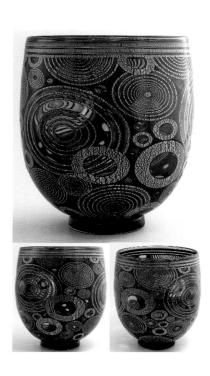

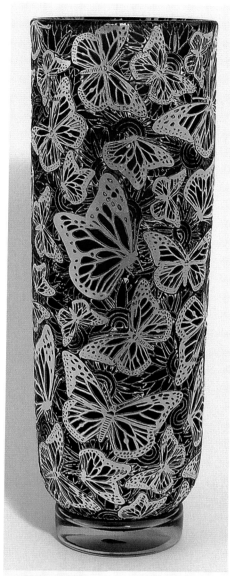

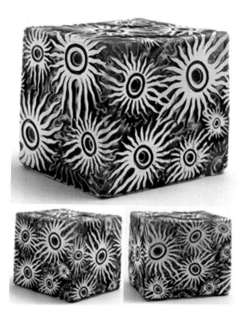

'Cameo'

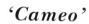

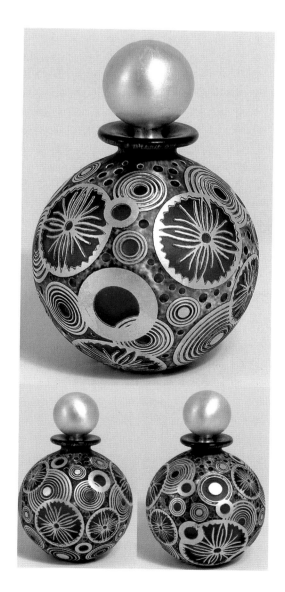

His work can be seen in galleries, exhibitions and private collections and comprises of a wide variety of techniques always pushing the boundaries with the material. His recent works are Graal and Cameo pieces.

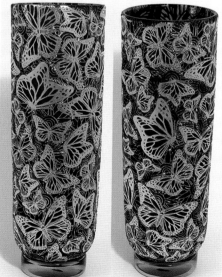

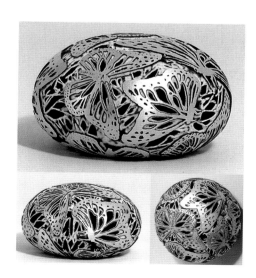

Tlws Johnson

After graduation in 1996 and with the help of a set up grant from Southern Arts, *Tlws Johnson* established her own studio making glass and ceramics in Gawcott, near Buckingham. She regularly exhibits with the Oxford Craft Guild, the Northampton Guild of Designers Makers and the Buckinghamshire Arts Society of which she is a full selected member.

Her work is organic and colourful and more recently has been based on ancient stones. The work is original one-off pieces with a few limited editions.

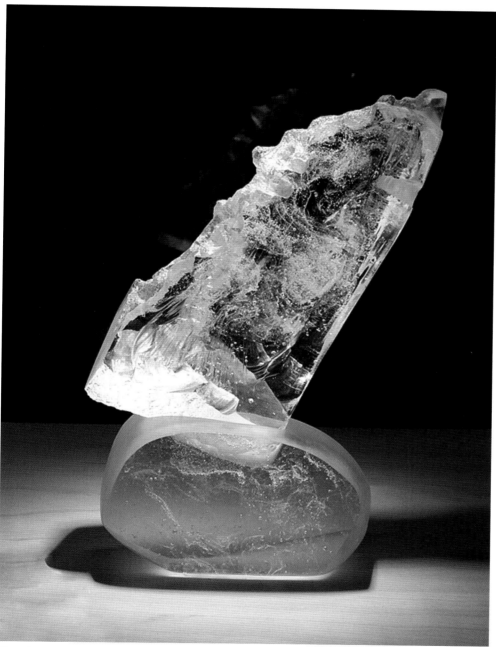

'Prow'

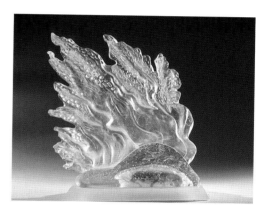

'Hidden Blue'

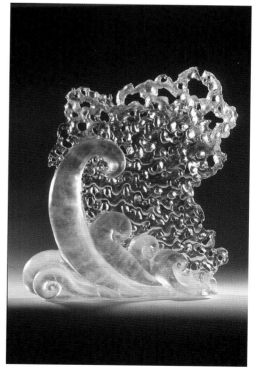

'Green Furl'

Vital Peeters

Vital Peeters was born in Turnhout, Belgium, and lives now in Oxford, England. In 1986, he graduated in Visual Studies and History of Art (BA Hons) from Oxford Brookes University. In 1992, he started his own stained glass studio by taking commissions and teaching classes. He also published a book: 'Stained glass, the art of crafts', Crowood.

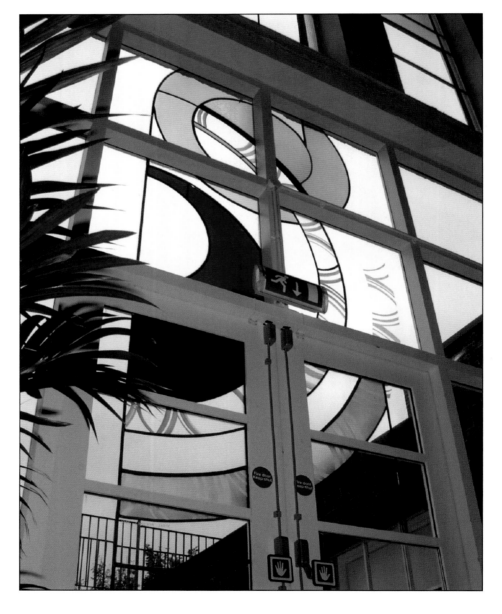

'Oxford Psychology Press 2' - This multiple window runs vertically across two floors of this open plan office façade. The design is seamlessly integrated into the fabric of the building.

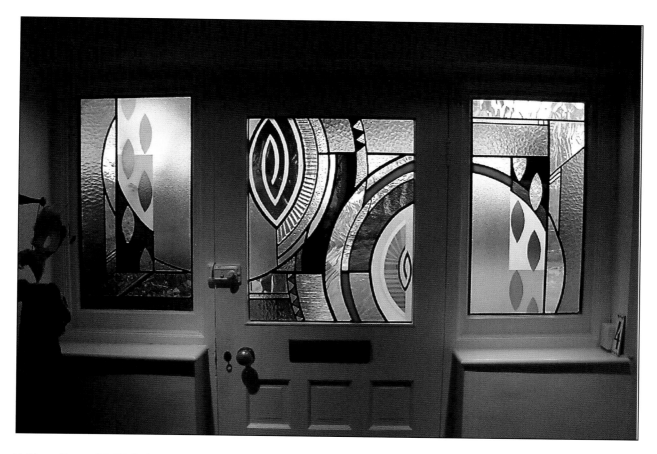

'African Door with Lights' - The earthy colours and simple motives of this door are inspired by African art and Art Deco. The ochre stain and brown art glass add warmth and texture.

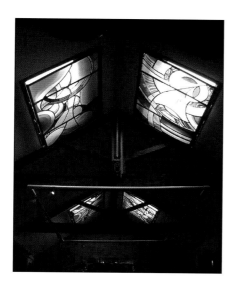

'Kitchen Windows' - These suspended stained glass windows are hinged at the top and backlit at night. The abstract design in each panel is based on the form of a fruit or vegetable.

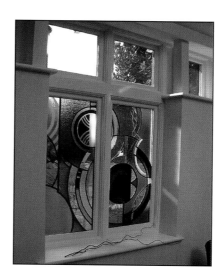

'Conservatory Panel' - This double window hides the view of a stone wall. The design has a rhythmic flow which is punctuated by the rich colours.

Vital's techniques are painting oxides and stains permanently fired into the glass, acid etching, sandblasting, screen printing, leading and fusing.

His style varies from constructivist and abstract to stylistic and figurative.

Zoë Gadsby

'Hot White', 2005

Zoë Gadsby explores and manipulates glass'
transformational qualities using vivid, luminous colour
and abstraction through geometric form, simple geometric
symbols and complex geometric pattern. These echo
naturally occurring chaotic forms and persistently
recurrent archetypal symbols; primal forms, abstractions of
colour and space both symbolic and literal.

Gadsby spent her early years in Hong Kong and returned to Scotland in the 1980s. Having graduated from the Environmental Art Department at Glasgow School of Art in 1995, her early instillation work explored light and colour and was influenced by meditational and experimental art. A further 2 years of study in Architectural and Kiln Formed Glass were a natural progression of this photography and sculpture based work.

'Red Rush', 2005

The United States

Michael Janis

Michael Janis first began working with glass as an architect in Australia, where his projects received international awards. Returning to the United States in 2003, he studied glass blowing and kiln-formed glass at Penland School of Craft, Haystack Mountain in Mai.

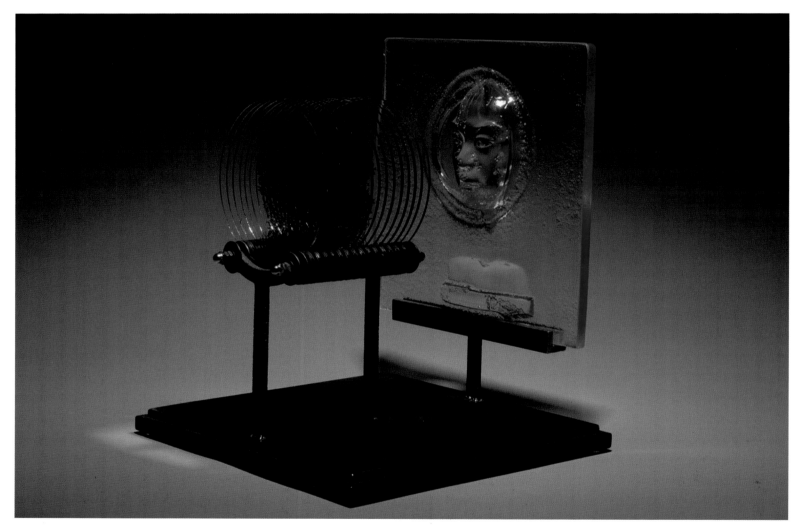

'Self Portrait'

His artwork and sculpture has been shown in numerous areas and regional galleries, and has work that is part of the permanent collection of the Art Institute of Chicago.

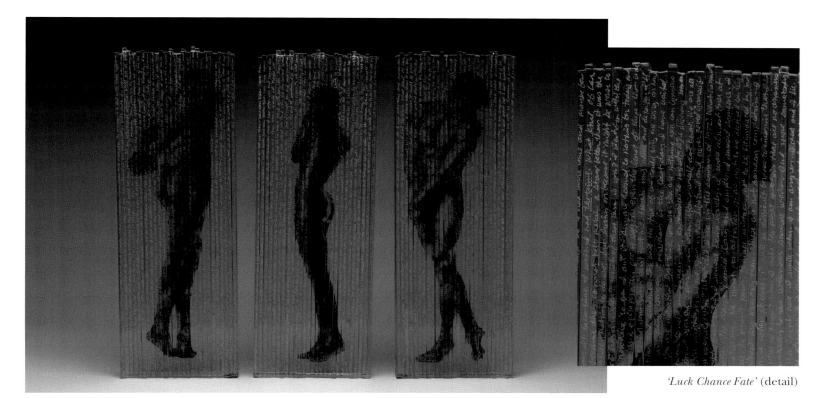

'Luck Chance Fate' (detail)

'Luck Chance Fate'

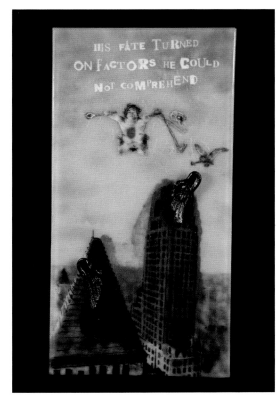

'Fall of Icarus'

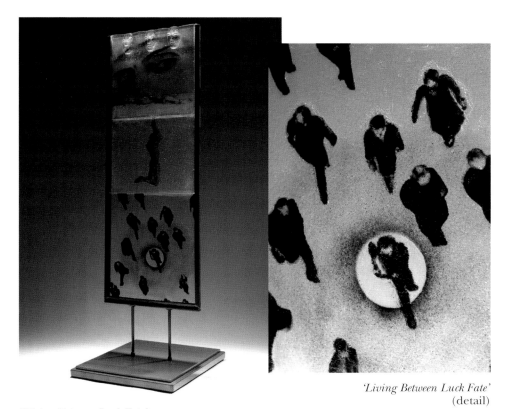

'Living Between Luck Fate'

'Living Between Luck Fate'
(detail)

Paul J. Stankard

Paul J. Stankard is internationally acclaimed as a pioneer and leader in the Studio Glass Movement. He has been working tiny miracles into glass for more than thirty-five years. Best known for transforming the traditional paperweight into a microcosm of exquisite natural beauty suspended in crystal, Stankard crafts fine art that illuminates his intimate and spiritual response to nature through glass.

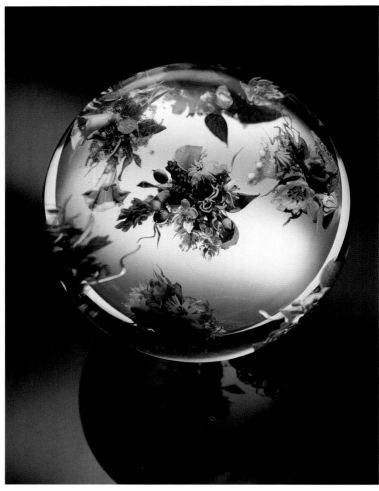

'Floating Bouquet Orb'

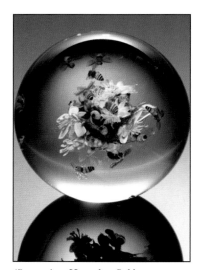

'Swarming Honeybee Orb'

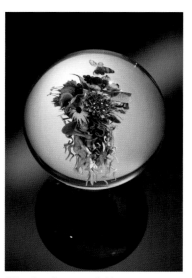

'Floating Bouquet Orb'

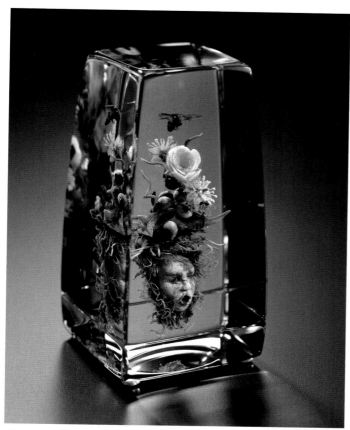

'Bouquet Botanical with Mask'

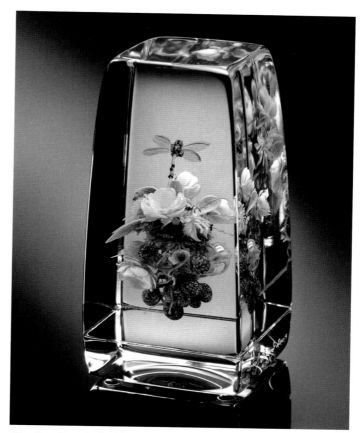

'Tea Rose Botanical with Damselfly'

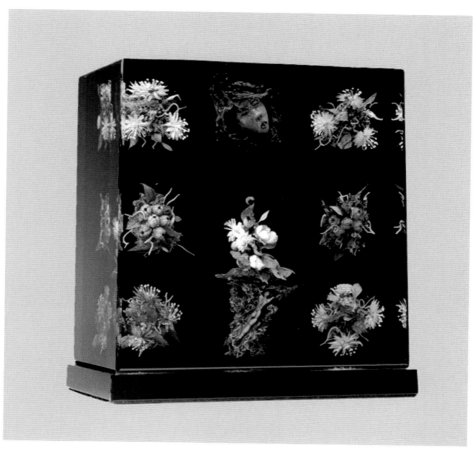

'Cloistered Assemblage Homage to Walt Whitman 2'

Robert Mickelsen

Born in 1951 in Fort Belvoir, Virginia and raised in Honolulu, Hawaii, *Robert Mickelsen's* formal education ended after one year of college. He apprenticed with a professional lamp worker for two years in the mid-seventies and then sold his own designs at outdoor craft fairs for ten years. In 1987, he took a class from Paul Stankard that opened his eyes to the possibilities of his medium. In 1989, he began marketing his work exclusively through galleries.

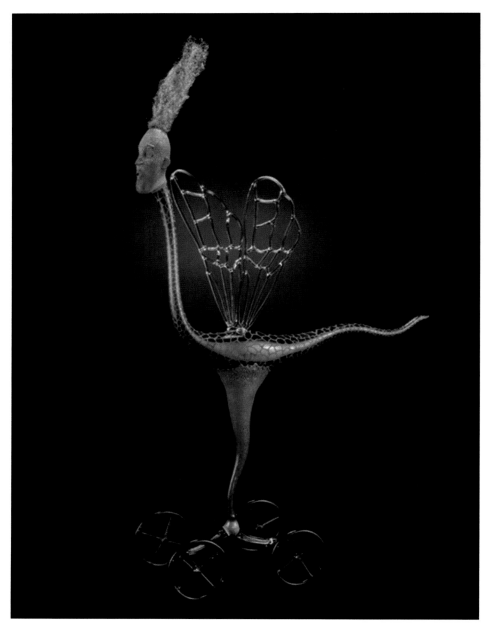

'*Trekker*', Personas series, 2004

Since then, his work is exhibited in many prominent collections including the Renwick Gallery of American Crafts at the Smithsonian Institution, the Corning Museum of Glass, The Toledo Museum of Art, The Carnegie Museum of Art, and the Pilchuck Glass School. Mickelsen has taught extensively at major glass schools including the Pilchuck Glass School, Penland School of Crafts, The Studio at the Corning Museum of Glass, and The Eugene Glass School. He has filmed and produced two videos on his flameworking process and has published numerous technical and historical articles on flameworked glass. He has served for six years on the board of directors of the Glass Art Society and was their treasurer and vice-president.

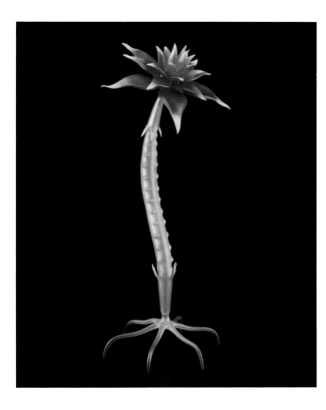

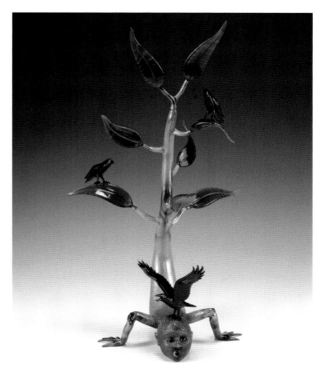

'Raven Man',
Personas Series,
2005

'Sirius Cluster',
Organism Series,
2005

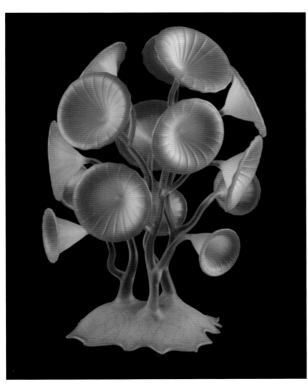

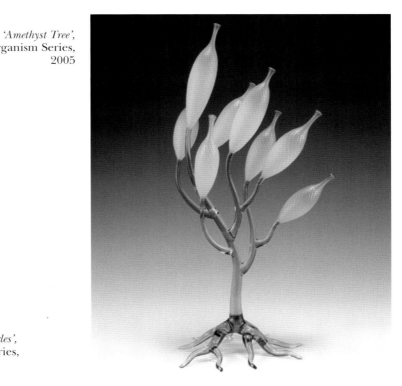

'Amethyst Tree',
Organism Series,
2005

'Flamingo Bugles',
Organism Series,
2005

Mickelsen's ideas are driven by subconscious thoughts, spontaneous fantasies, and dreams. Some recent work features layering of colours combined with resist sandblasting to create images, a technique called 'graal'. Other new work emphasises his interest in organic shapes and surfaces by sandblasting to achieve a specific texture which he then highlights with colour gradients done in oil paints. The resulting surfaces are translucent, glowing, and invitingly touchable.

Another body of his work utilizes characteristics of glass that are deliberately not 'glass-like' to yield rough, organic surfaces and forms. His latest work series portrays the inner exploration of self and is called the 'Personas'.

Stephen Dee Edwards

Stephen Dee Edwards' work represents his ongoing fascination with nature and our relationship to it. The figure, birds, and abstract natural forms are used to promote meditation on nature, structure and material. He uses glass to express his ideas as it exemplifies the fragility of nature. The transparency of the material is important to him as it facilitates the illusion of looking through water at an image. The glass magnifies and sometimes distorts images and puts them into a dream-like state. He has always been fascinated with the colours and textures found in nature. He attempts to convey his feelings about natural forms, textures and colours through his glass sculptures.

'Bi Fold'

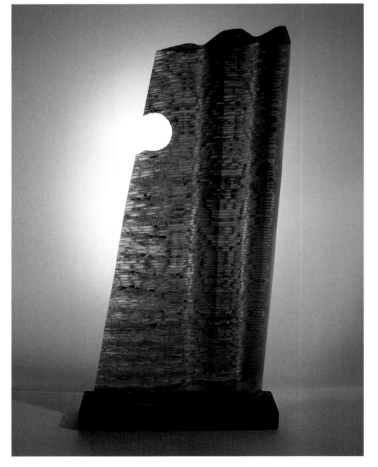

'Large Grouping'

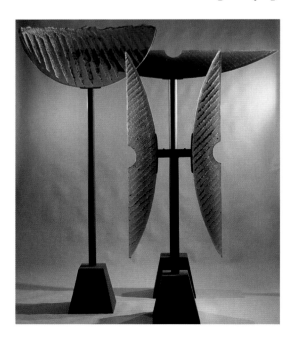

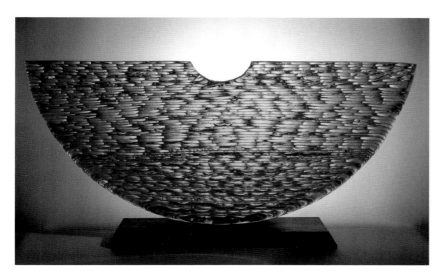

'Blue Slice'

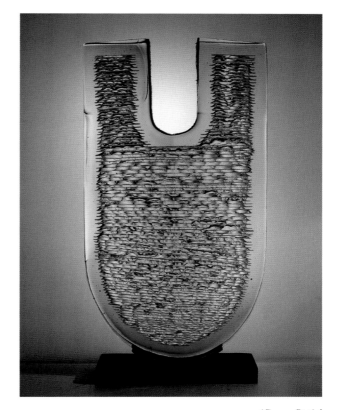

'Green Optic'

'Orange Faceted Swoop'

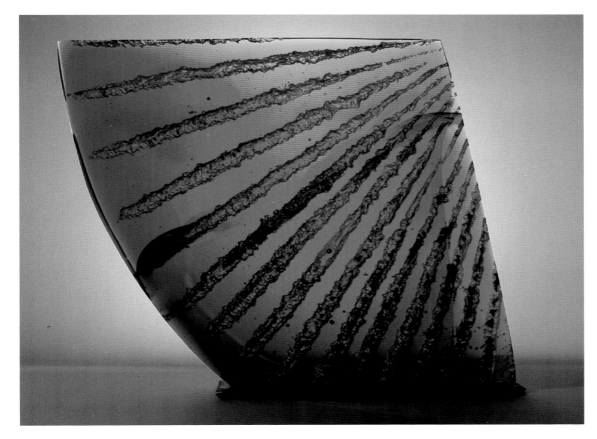

Tim Drier

Born in Port Huron, Michigan, *Tim Drier's* interest in glass came from his father and his profession in scientific glassblowing has continued for more than 21 years. He was certified in scientific glassblowing from Salem community college in 1984, and joined his father in a business venture (Drier Glass) performing repairs, custom building and modification of scientific glassware.

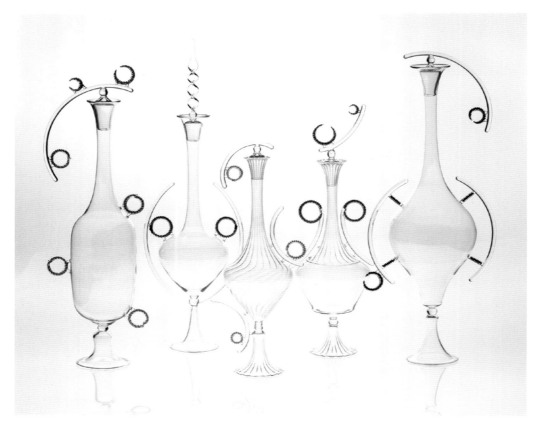

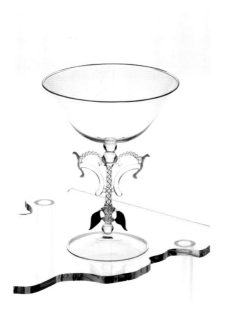

Drier joined Eastman Kodak Company in 1987, and continued education in larger and more complex scientific glass apparatus. In 1989, he returned to Michigan and joined the Dow Chemical Company, where he works today, mainly with borosilicate glass to design and create complex scientific glassware for research and industrial chemical endeavours.

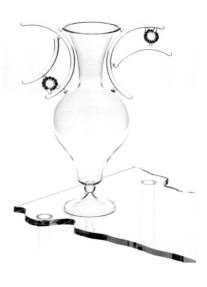

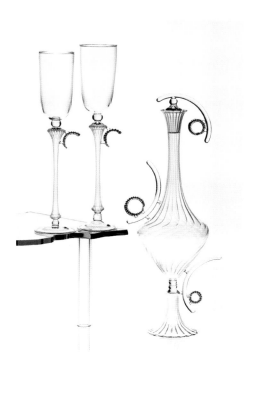

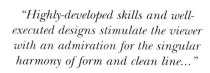
"Highly-developed skills and well-executed designs stimulate the viewer with an admiration for the singular harmony of form and clean line..."

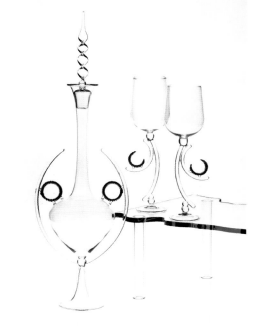

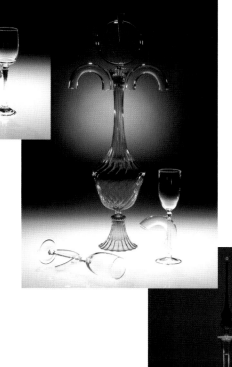

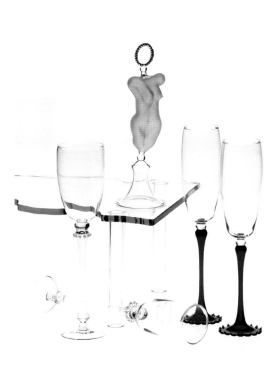

Tim Tate

Tim Tate is a Washington DC native, and has been working with glass as a sculptural medium for the past 25 years. His work deals heavily with healing and memory... and much specifically dealing with the fact that he has been HIV+ for 22 years.

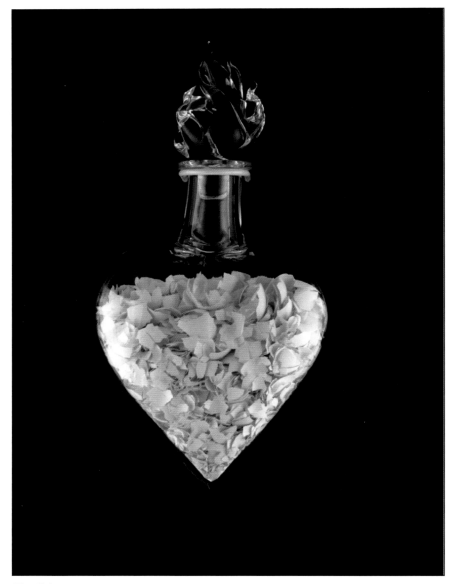

'Fragile'

Co-Founder of the Washington Glass School, Tate's work is in the permanent collections of a number of museums, including the Smithsonian's American Art Museum and the Mint Museum. He was named 'Outstanding Emerging Artist for Washington, DC' in 2003 and was one of OUT Magazine's 100 People of the Year in 2004. He was the subject of recent articles in American Style and Sculpture magazines, as well as the Washington Post and Times newspaper reviews.

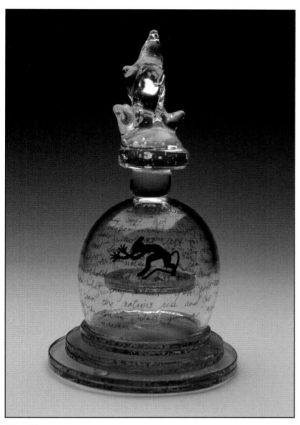

'Devil'

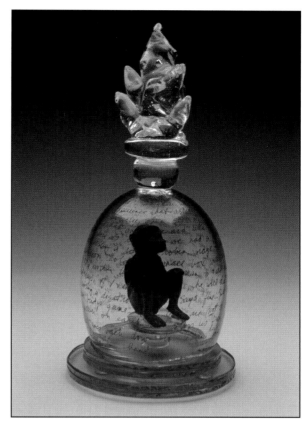

'Monkey'

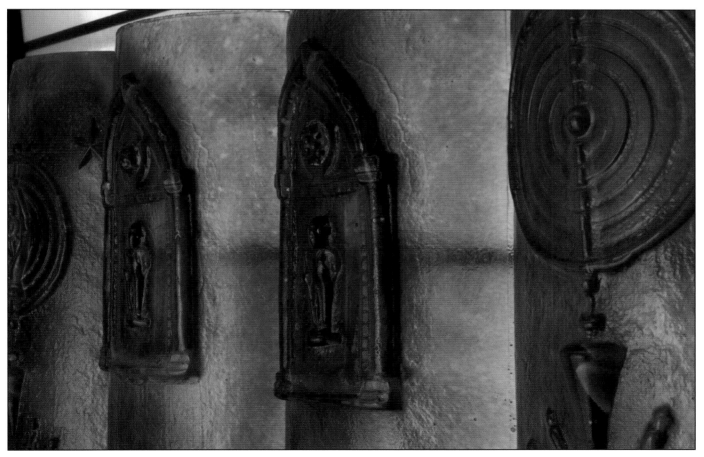

'Curved Panels'